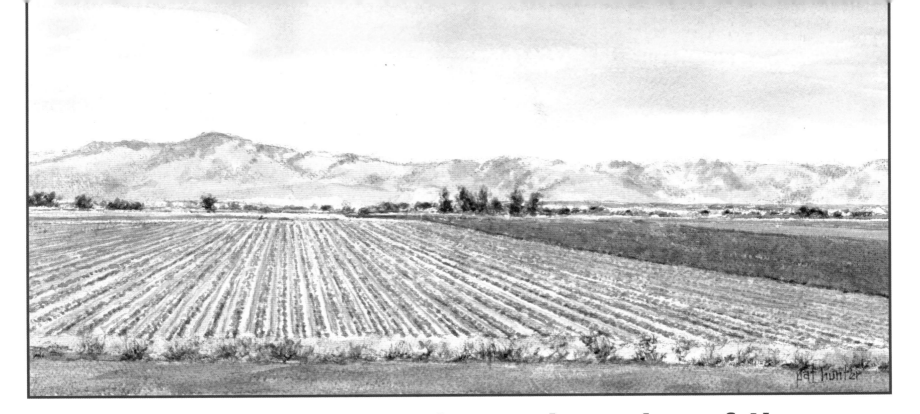

Landscapes and Landmarks of the
Great Central Valley

paintings by Pat Hunter and text by Janice Stevens

CRAVEN STREET BOOKS

B O O K S

Fresno CA

Landscapes and Landmarks of the Great Central Valley

Published by Craven Street Books,
an imprint of Linden Publishing.
2006 S. Mary, Fresno, California, 93721
559-233-6633 / 800-345-4447
CravenStreetBooks.com

Craven Street Books is an imprint of Linden Publishing, Inc.

Craven Street Books titles may be purchased in quantity at special discounts for educational, fund-raising, business, or promotional use. Please contact Craven Street Books at the above address or phone numbers. To order another copy of this book, please call **1-800-345-4447**.

ISBN 9781610353625

135798642

Printed in China.

Library of Congress Cataloging-in-Publication Data on file.

Contents

Preface

Landscapes and Landmarks of the Great Central Valley grew from a passion Pat and I share of recording history, preserved and showcased in Pat's watercolor paintings or in my text on the page. Thus we embarked on an adventure of capturing the essence of our home town in our first two books, *Fresno's Architectural Past, Volumes I* and *II*, in order to emphasize its historic importance in a collaboration of art and words.

When Fresno's plans began to emerge to celebrate the centennial of literary great William Saroyan, Fresno's native son, another partnering was in order: *William Saroyan: Places in Time*. We revisited his childhood home, and came to appreciate his love for his birthplace, featured in much of his literary work.

Then, with a suggestion from our publisher to travel beyond the perimeters of the San Joaquin Valley, we set out to research and revisit all twenty-one California missions and their *assistencias*, from the first mission founded in San Diego to the last one in Sonoma, culminating in our book *Remembering the California Missions*.

Another suggestion from our publisher saw us traveling the length of Highway 1, recording the sights of the state's stunning coastal boundaries from the Oregon border to the Mexican border. The result was a trilogy: *An Artist and a Writer Travel Highway 1 North, Central*, and *South*. Pat and I both grew up on the beaches of California and couldn't resist the opportunity to return to Santa Cruz, my childhood home, and Pat's long-time home of Southern California.

Re-entering the San Joaquin Valley after each book's research trip, we would reflect on the fascinating history we encountered and the beauty of the state. We welcomed the home stretch, whether viewing the vast valley coming down from Pacheco Pass or seeing it open before us from the Interstate 5 Grapevine or, perhaps, returning from the Gold Country on Highway 49, or from Pat's teaching a painting workshop in Yosemite National Park. Home has a way of tugging at our emotions, and much as we relish our "getaways" to gather material for our books, we always give a contented sigh to be home again.

That teasing notion of home began to gnaw at us. Why not do a book on our Valley? We could travel the entire Great Central Valley, bounded by mountain ranges to the east, west, north, and south, and view the bounty of agricultural wealth extended in giant geometric patterns across large swaths of land.

Pat began painting these scenes long before we had a publishing contract in place. The San Joaquin Valley is home, and she was driven by an intense determination to paint its landscapes and landmarks, to offer a tribute and leave a legacy to the place she cherishes.

This is an art book, where every painting tells a story of love and devotion. Here we share the Great Central Valley, from Tejon Pass to Mount Shasta with you, our readers, with the hope you, too, will glean a deeper appreciation of California's heartland.

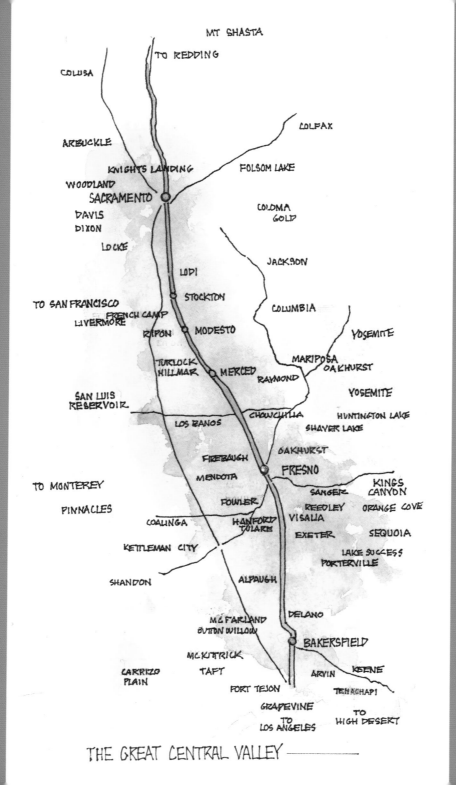

THE GREAT CENTRAL VALLEY

Introduction

THE GREAT CENTRAL VALLEY extends over approximately 450 miles of predominately flat land, stretching from Tejon Pass in the south to Mount Shasta in the north. This fertile region, bounded by the Tehachapi/Emigdio Mountains on the south, the Klamath Mountains on the north, and nestled between the Coastal Mountains on the West and the Sierra Nevada on the East, gives birth to one of the richest agricultural regions in the world.

Indeed, "From Farm to Fork" is the motto of Sacramento, home to California Expo, the state fair that showcases the bounty produced from this rich heartland. The beauty that is "the Valley," as it is affectionately referred to, doesn't lie just in its varieties of crops, but also in the mountain range boundaries encasing the Valley. Here from the San Joaquin Valley, mid-center of the state, one could drive west two or three hours and reach the Pacific Ocean. Travel two to three hours east, and one could be in the Giant Sequoias or Yosemite.

Crisscrossing California, the San Andreas Fault dissects the eastern and the western state, running parallel to Highway 101 and Interstate 5. Throughout the Central Valley, the fault plays a prominent role; one community, Parkfield, has become a hub for monitoring and tracking seismic activity.

Within the Great Central Valley, historical markings by the indigenous peoples of California are frequently found, such as the pictographs of Soda Lake in the Carrizo Plain, or the culture-depicting illustrations in the Wassama Round House and the Grinding Rocks in the Sierras.

The Old Ridge Route through the Tejon Pass begins the journey north, and from there, passing through the Great Central Valley, one discovers a seemingly endless series of landmarks and landscapes, the journey culminating near the top of the state of California at Mount Shasta. The Old Ridge Route traversed across a path established first in 1772 by Spanish explorer Pedro Fages, during the dawn of the California missions era. He is credited with naming the pass "Tejon" after a dead badger he discovered on his journey. Later, renowned explorer Jedediah Smith used the pass on his travel from Antelope Valley to the San Joaquin Valley.

A link was established between Southern and Central California with the 1915 opening of the Old Ridge Route, a concrete-paved road featuring harrowing mountain curves and steep grades carved out by Fresno Scrapers. The road has been placed on the National Register of Historic Places due to its significance in maintaining commerce between the south and central portions of the state. An alternate route shortened the distance and eliminated some of those dangerous curves in 1929. This was followed by the construction of Highway 99, which later was widened and evolved into Interstate 5.

Historical Fort Tejon is located off Tejon Pass in the Grapevine Canyon off Interstate 5 in Kern County. The freeway runs between the San Emigdio Mountains and the Tehachapi Mountains, the two ranges that separate the Valley from the Los Angeles Basin and southern California.

The Great Central Valley comes into view as one begins the descent from the summit of the Grapevine. To the west of the Grapevine, the Carrizo Plain in the spring boasts vibrant colors of yellow, orange, pink, blue, and lavender, its wildflowers spanning more than 246,000 acres.

Kern County extends across the southern Valley at the base of the Tehachapi, and is home to oil wells positioned across the landscape as far as the eye can see. The towns of McKittrick and Taft and are major sources of oil and gas production.

Small towns clustered across the Valley, such as Weedpatch, tell the history of how the Valley grew to become one of the richest agricultural areas in the world, boasting orchards of fruits and nuts; vegetables; berries and melons; and field crops such as wheat and alfalfa, rice and hay.

Along the way, landmarks attest to the history that abounds in the Great Central Valley. For example, Colonel Allensworth offers a historical glimpse into an all-black community founded in 1908. Now a California State Park, the remaining buildings have been meticulously preserved and restored.

Heading east from Visalia, the Sequoias National Park rises above the Valley with soaring redwoods. With the park is the world's largest tree, the General Sherman at the north end of the Giant Forest. In the adjacent Kings Canyon National Park, one can visit the General Grant tree, the second largest tree in the world, located in General Grant Grove.

The San Joaquin Valley's Fresno County is one of the largest counties in California, both in size and in population. Rated number one in the nation in agricultural production in 2019, "Farmers and ranchers in Fresno County produced a record value of $7.88 billion in crops and commodities last year, up from $7.02 billion in 2017," notes *The Fresno Bee*. The county's more than 300 different crops provide food and fiber nationwide and to more than 95 countries around the world.

Home to literary great William Saroyan, who featured Fresno in many of his writings, the city's numerous well-preserved historical landmarks include the Fresno Water Tower and Warnor's Theatre, both of which are noted on the National Register of Historic Places as well as on the California Register of Historic Resources.

Continuing north through Madera County, evidence of the early settlement of California remains in landmarks such as the Madera Courthouse, built from Raymond's quarry. Farther north, the small town's quarry continues to provide rock to build the homes and buildings of the Valley, much as it has since the early 1880s.

Of note in Merced County, in the eastern portion of the Diablo Range of the Coastal Range Mountains, is San Luis Dam. Built between the years 1963–1968 in a joint project by the state and federal governments to create the Central Valley Project, the vast basin provides water to Los Angeles County. The dam forms the San Luis Reservoir,

the largest off-stream reservoir in the United States. The San Joaquin and Sacramento Rivers, which merge into the San Joaquin/Sacramento Delta, aided by extensive reservoirs and canals featured in the Central Valley Project, irrigate the Valley's far-flung 7 million acres of land.

To the northeast, Yosemite National Park, with its towering granite monoliths, draws tourists from around the world. Visitors come to gaze at cascading waterfalls, camp, and hike trails deep into the wilderness to explore the park's beautiful scenery.

North of Yosemite, remnants of the Gold Country trace California's history back to before the mid-1800s. Here one will find restored mining towns, such as Columbia, with its theater and Wells Fargo Bank, from which visitors can board stagecoaches pulled by teams of horses and experience what travel was like more than a century ago.

Chinese influences can be found in Locke, a town built along the Sacramento Delta by Chinese for the Chinese. East of the Delta, the town of Lodi welcomes the sandhill cranes, as the picturesque birds make their migratory way from the Great Plains to Siberia, stopping a while in the marshes and swamps along the Delta, which provides an ideal resting point during their migration.

Sacramento takes one to the home of California's government, housed in the elegant state capitol building. Other historical buildings remain in this county, a center of transportation and industry. Of particular note is the Leland Stanford Mansion, a historic site reminiscent of the ornate architecture of the Victorian

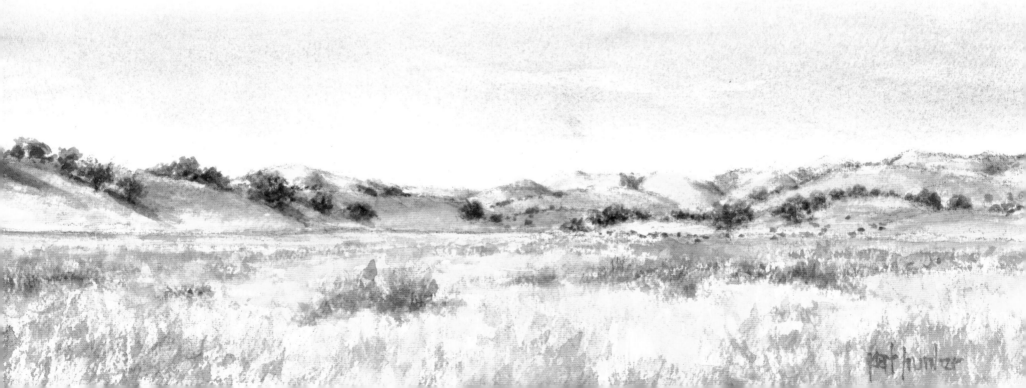

period. Today, the Mansion is a California State Park and is listed on the National Register of Historic Places.

Northwest of Sacramento, the Woodland Opera House continues to provide entertainment to the community. The original opera house, built in 1885, burned down and was rebuilt within a year. The building is listed on the National Register of Historic Places, and as a California Historical Landmark, for its significance as one of only four opera houses in California remaining from the 19th century.

Finally, is the northernmost landscape of the Great Central Valley, where Mount Shasta in Siskiyou County rises above the land, a potentially active volcano in the Shasta Trinity Mountain Forest in the Cascade Range.

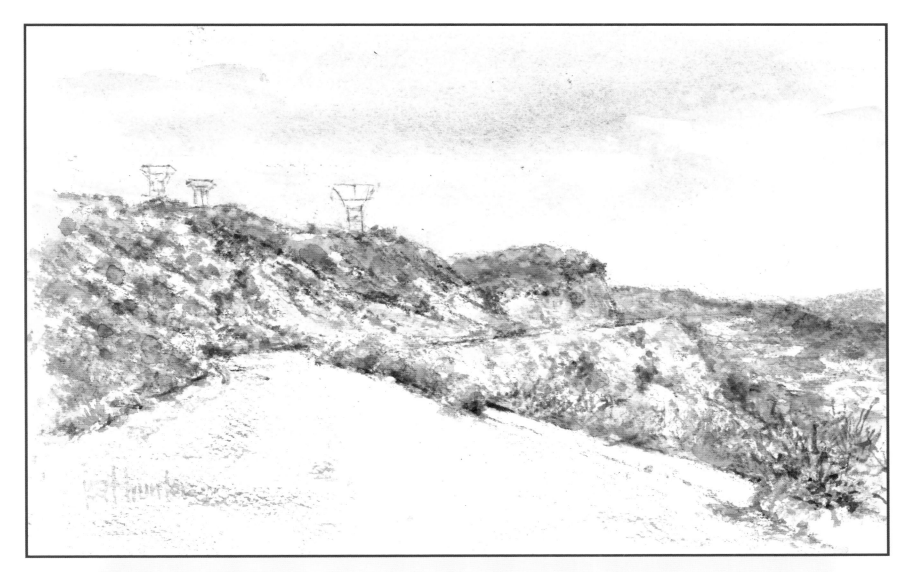

1 The Old Ridge Route

The Old Ridge Route opened up passage through Tejon Pass from Southern California to Central California. A seventeen-mile stretch remains of the concrete paved road on the ridge of the Tehachapi Mountains, a steep graded climb with notorious blind curves. Placed on the National Register of Historic Places for its historical significance, the Old Ridge Route is closed at the request of the Los Angeles Forestry Service.

2 Fort Tejon State Historic Park

This former United States Army outpost is located off Interstate 5 in the Grapevine Canyon between the San Emigdio and Tehachapi Mountains. Built in 1854, the fort served as a protection against Californios, California's early Spanish-speaking residents prior to statehood, and Native American Paiute and Mohave tribes. Scattered villages of Emigdianos lived near the Fort but were considered less aggressive than the others. The Fort housed the First U.S. Dragoons—until they transferred to the East at the outbreak of the Civil War in 1861. Volunteer troops stayed at the fort until it permanently closed in 1864. Fort Tejon is listed on the National Register of Historic Places. The remaining buildings are either restored or left in "arrested decay," meaning that they are stabilized but not restored. Two are open for visitors: the Barracks display military uniforms in glass cases, and the Commanding Officer's Quarters feature two furnished rooms.

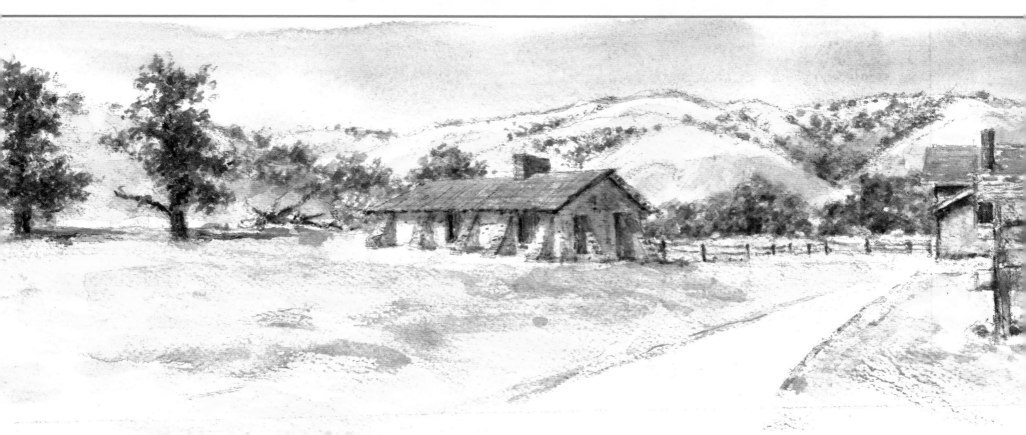

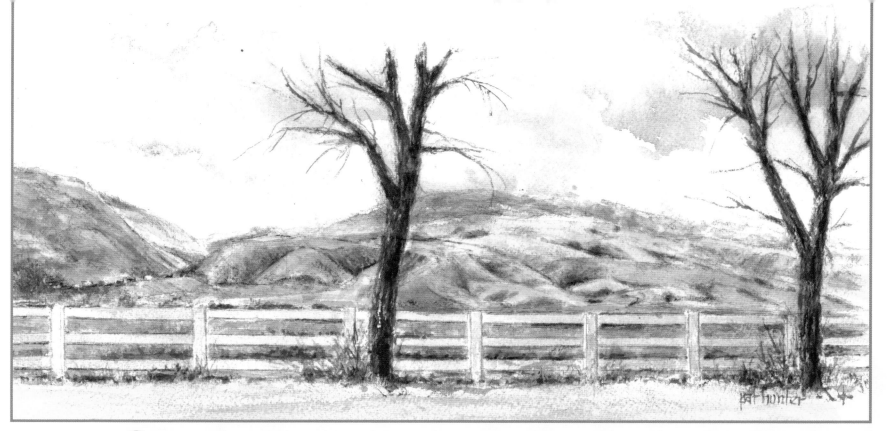

3 The Tejon Pass

The Fort Tejon Pass, between the southwest end of the Tehachapi Mountains and the Emigdio Mountains, commonly known as "The Grapevine," is a well-traveled link between Southern California and Central California.

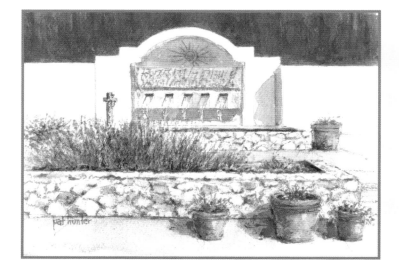

4 The Chavez Monument

The Cesar E. Chavez National Monument in Kern County, approximately thirty miles from Bakersfield, was the former home of Chavez and his wife, Helen Fabela, and the headquarters of the United Farm Workers. Chavez and his wife are buried on the 116-acre property. The National Chavez Center on the grounds features memorabilia and exhibits depicting the history of the United Farm Workers and their historic efforts to improve labor conditions for their workers.

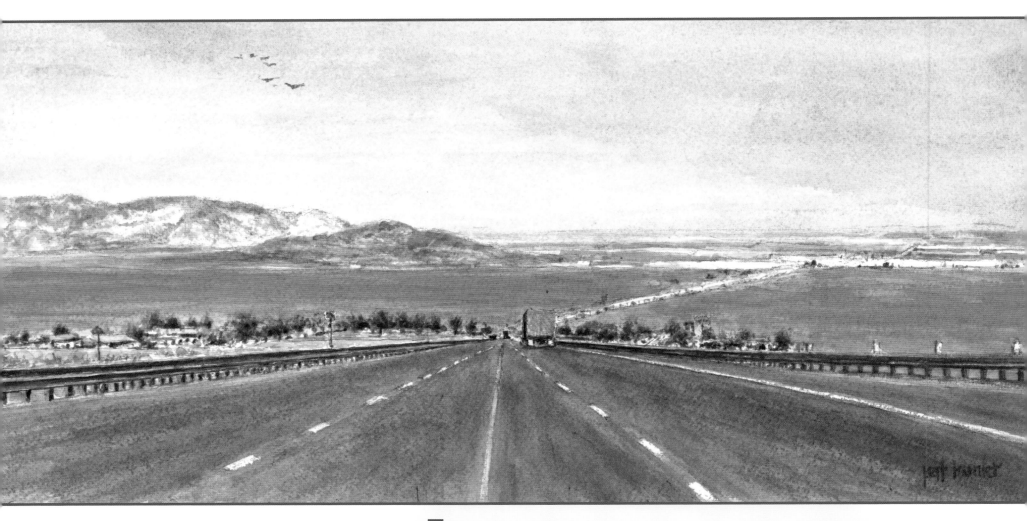

5 The Great Central Valley

Facing north after descending Interstate 5 to the bottom of the steep Grapevine grade, the Great Central Valley beckons with a vast panoramic view of a lush patchwork of agricultural fields.

6 The Tehachapi Loop

Looking down on the rail line from Keene Post Office and Store, one can see the famous Tehachapi Loop traverse through the Tehachapi Pass of its namesake mountains. It has been described as a long spiral or helix on the Union Pacific Railroad Mojave Subdivision that connects Bakersfield to the Mojave Desert. An estimated forty trains, each more than 4,000 feet long, make the loop daily, doubling above themselves as they pass through Tunnel Nine. Southern Pacific Railroad began construction on the unusual configuration—long considered an impressive engineering feat for its time—in 1874. Three thousand Chinese laborers with primitive tools such as picks, shovels, and horse-drawn carts, and with the aid of blasting powder, tunneled through granite to create the loop, which consists of eighteen tunnels, ten bridges, and various water towers for the steam engines.

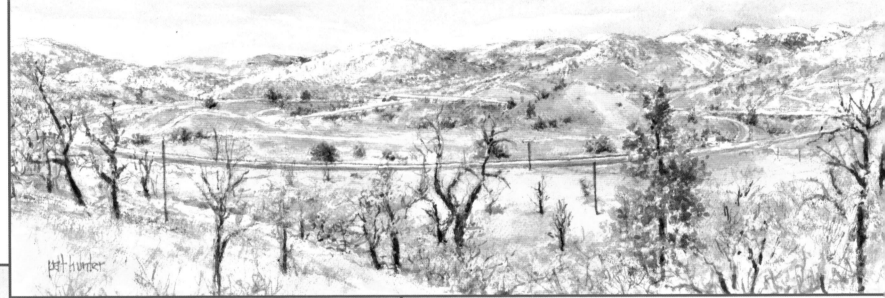

7 The Keene Café

The Keene Café, located at the top of the hill overlooking the Tehachapi Loop, was established in the 1920s. By the 1930s, the café had become a boarding house for miners working the limestone and kilns at Tweedy Canyon. Ethel Stuck then acquired the building and restored it to its original café use. By the 1940s, military stationed in the area to protect the railroad tunnels and bridges frequented the café. The café has continued serving customers, featuring its trademark wildflower displays and home-cooked meals.

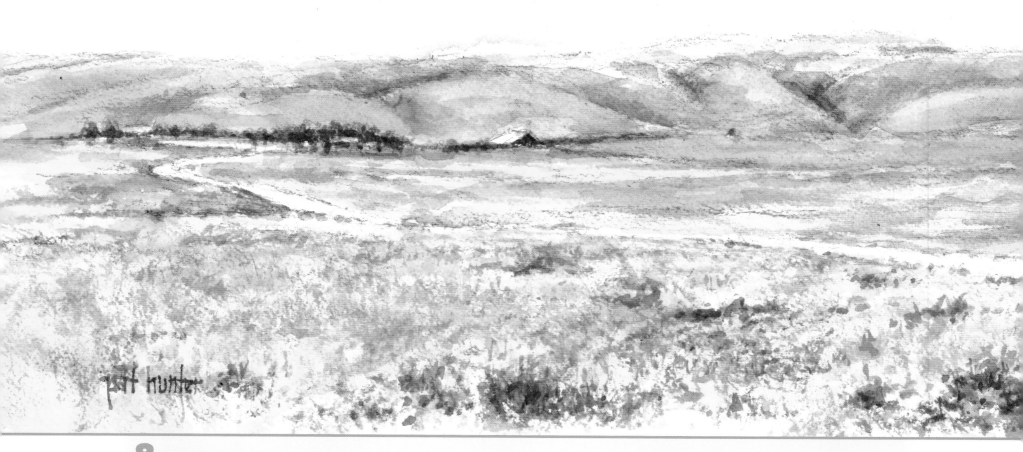

8 The Carrizo Plain

Tucked between the Temblor Range on the north and the Caliente Range on the southwest, the Carrizo Plain in San Luis Obispo and Kern Counties is approximately fifty miles long and fifteen miles across. The Carrizo Plain National Monument within the plain consists of 246,812 acres, and is considered to be the largest single native grassland in California. The infamous San Andreas Fault runs through the plain. The Carrizo Plain Rock Art Discontiguous District is listed on the U.S. National Register of Historic Places. The sandstone alcove contains pictographs made by Chumash and Yokut Indians that are estimated to have been created circa 2000 BC. In the spring, a mass of lupine, California poppies, and monolopia blanket the plain, creating a vibrant display of color.

9 The Carrizo National Monument Sign

The Carrizo National Monument sign affirms the region's National Monument status, designated by President Clinton in 2001. In 1988, the United States Bureau of Land Management, the California Department of Fish and Game, and the Nature Conservancy partnered to purchase the 82,000-acre land parcel to protect the Carrizo Plain. The Carrizo Plain is accessible off State Route 166 (south entrance) and State Route 58 (north entrance). Soda Lake Road is the only passable course through the Plain, but a section of the road is gravel and might be inaccessible during a rain.

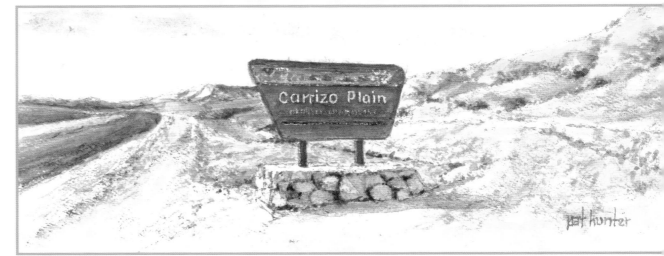

10 Weedpatch

South of Bakersfield in the small town of Arvin, with a population of less than 20,000, the remnants of a significant moment in California history have been carefully preserved. Three buildings of the Weedpatch Camp remain: the community hall, the post office, and the library, all acknowledged on the National Register of Historic Places. Memorialized in John Steinbeck's book *The Grapes of Wrath*, the Weedpatch Camp, also known as the Arvin Federal Government Camp and the Sunset Labor Camp, was constructed in 1936 by the Works Progress Administration (WPA). The camp housed migrants—mostly from Oklahoma, but also from Texas, Arkansas, and Missouri—fleeing the Dust Bowl during the Great Depression.

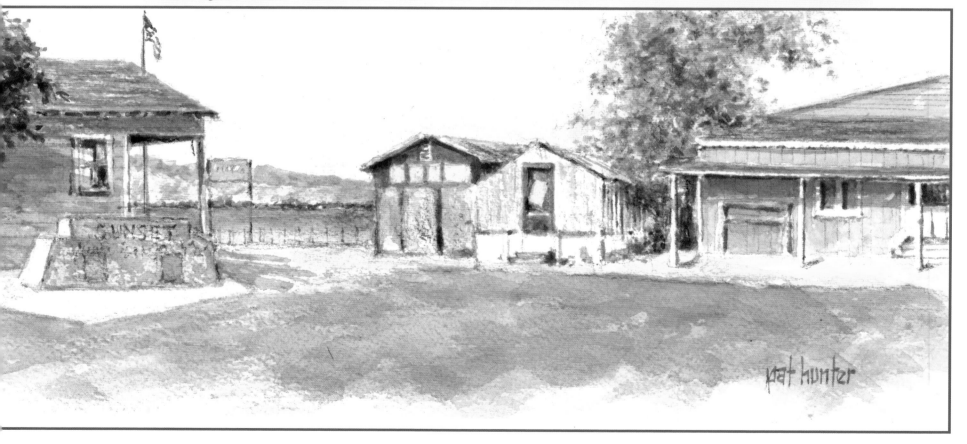

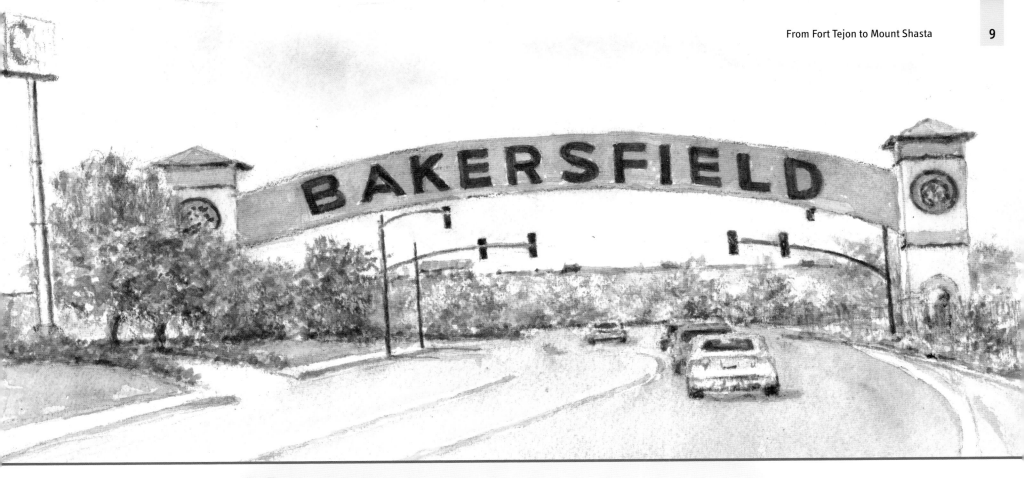

11 Bakersfield Street Sign

Bakersfield, the county seat for Kern County, encompasses about 142 square miles near the south end of the San Joaquin Valley. Kern County is reputed to be the most productive oil producing county in the United States.

The Bakersfield Sign, built by California Neon Sign Company, arches over Sillect Avenue and intersects with Buck Owens Boulevard. The iconic landmark was constructed in 1949 and renovated in 1999. The two towers that support the steel structure are patterned after the Beale Memorial Clock Tower, which is also located in Bakersfield.

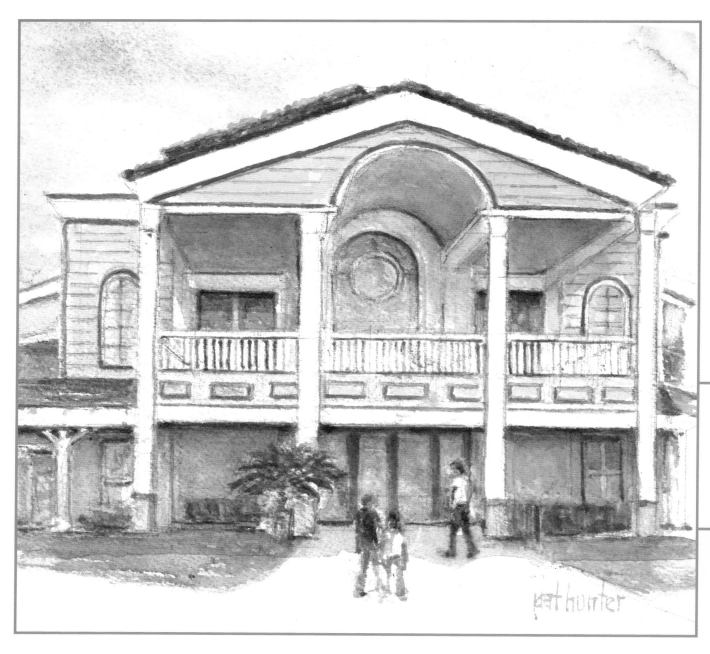

12 Buck Owens' Crystal Palace

A destination restaurant, enjoy perusing the collections, shopping at the gift store, and indulging in a mouthwatering buffet brunch on a Sunday. Dubbed the Buck Owens Museum, glass cases line the large restaurant, filled to capacity with mementos from Buck Owens' legendary country music career, including his original red, white, and blue guitar.

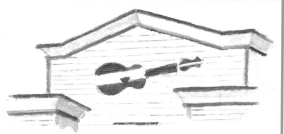

13 Guitar Symbol

The image on the wall of the Crystal Palace is symbolic of the trademark red, white, and blue guitar made famous by Buck Owens.

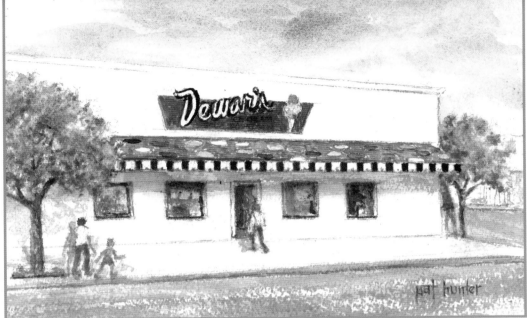

15 Woolgrowers

The Woolgrowers Restaurant, located at 620 E. 19th Street in downtown Bakersfield, opened in 1954. Owned and operated by family, the Basque restaurant serves regional foods in a family style atmosphere.

14 Dewar's Candy Shop

Located at 1120 Eye Street in Bakersfield, Dewar's Candy Shop was founded in the early 1900s by the Dewar family. It moved about to several different communities in California before settling into its present location in 1930, where ice cream was introduced to the menu. With the participation of new family members in the 2000s, five generations can now claim ownership of Dewar's signature candy and ice cream.

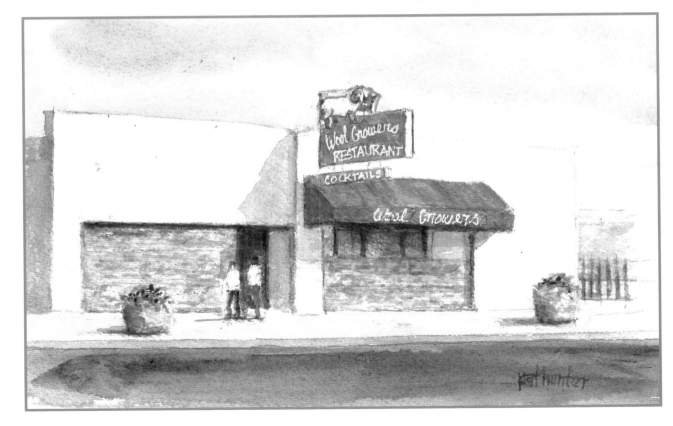

16 McKittrick

The town of McKittrick, at the junction of California State Routes 33 and 58, lies southeast of the vast McKittrick Oil Field and other oil and gas fields in this remote area. North of McKittrick, the Cymric Oil Field and the Midway–Sunset Oil Field are together considered to be the third largest oil field in the United States.

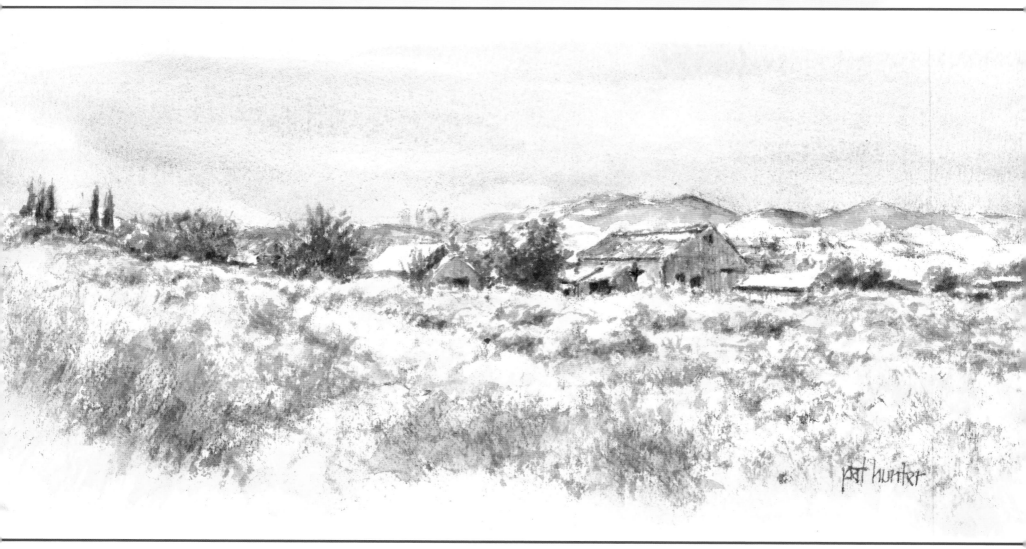

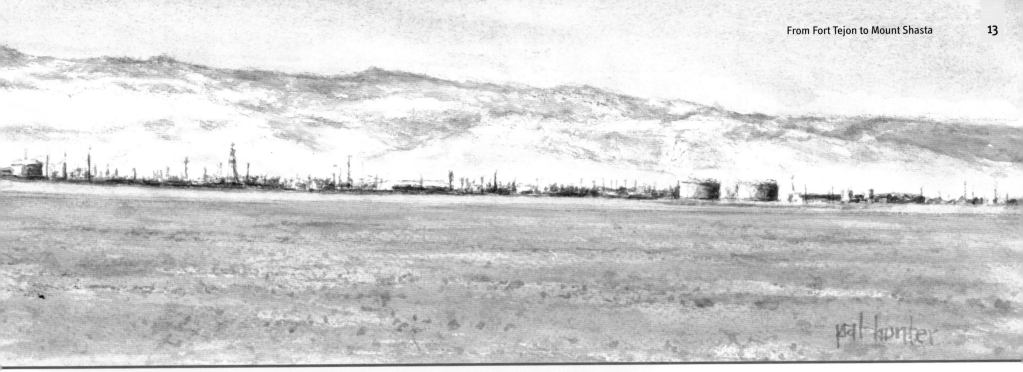

17 McKittrick Oil Wells

Travelers are accustomed to oil wells along many roads in the Valley, but the unusual sight of the hundreds of oil wells in these fields illustrates the wealth of natural resources found in this region of California.

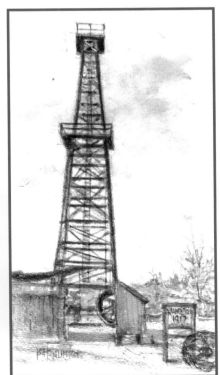

18 The West Kern Oil Museum

The West Kern Oil Museum in Taft features a 106-foot-tall reproduction of a 1939 wooden oil derrick named The Bender Rig. Antique oil machinery throughout this outdoor museum reflect Taft's rich oil industry heritage.

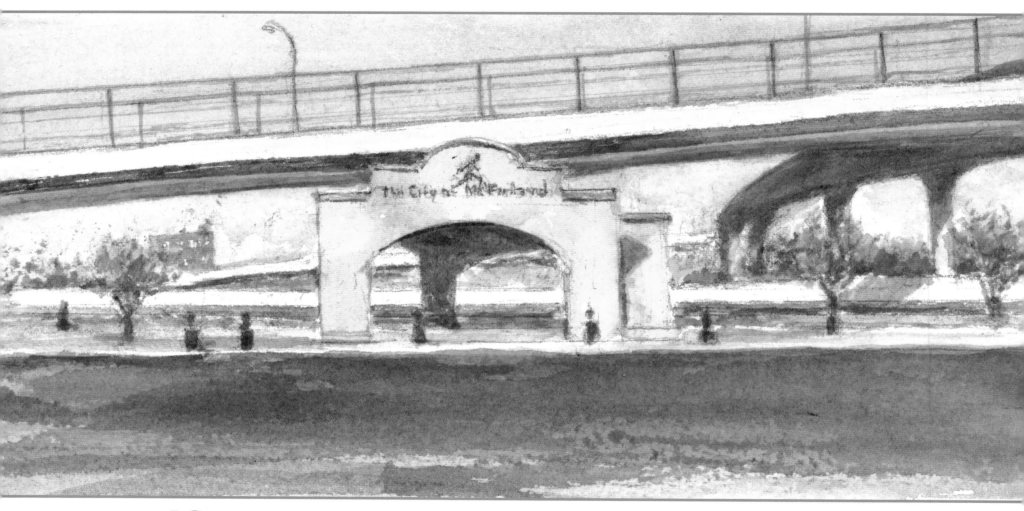

19 McFarland

McFarland is located twenty-five miles northwest of Bakersfield in Kern County. This small farming community was made famous by the film *McFarland, USA*, which was co-produced by Walt Disney Pictures and Mayhem Pictures. The film tells the true story of a McFarland high school's predominately Latino cross country team winning, against all odds, the 1987 state championship in their sport.

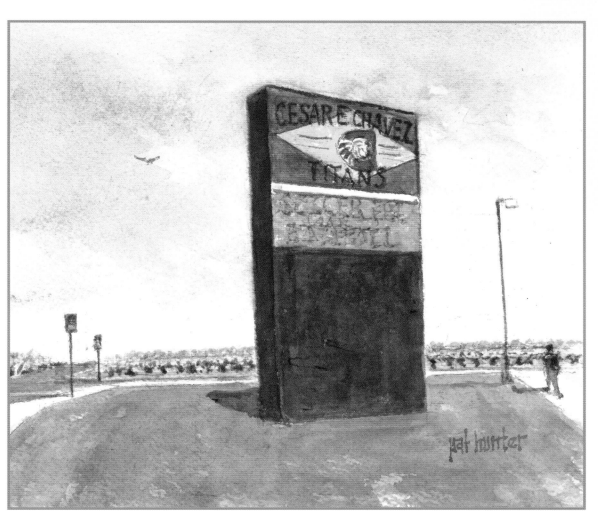

20 Cesar Chavez Sign in Delano

The Cesar Estrada Chavez sign on the marquee of Delano High School commemorates the Agricultural Workers Organizing Committee and United Farm Workers labor strike led by Chavez, along with Dolores Huerta and Richard Chavez. The strikers marched from Delano to the Sacramento State Capitol to protest poor working conditions; their efforts eventually resulted in signed labor contracts more than five years later.

21 Colonel Allensworth State Park School

Colonel Allensworth, a historic village in the middle of desolate fields, is named for Lieutenant Colonel Allensworth, who along with a minister, a miner, and a real estate agent, established the all-black community in 1908 for African Americans. The small community depended on agriculture, but with a drop in the area's water table, the crops failed, and gradually the inhabitants abandoned the town. The school house is one of the few remaining buildings.

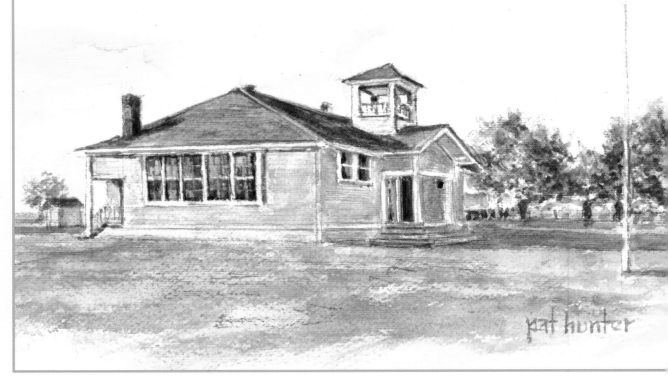

22 Allensworth Library

The library at Allensworth dates back to the early 1900s, and is one of nine historic buildings that remain to attest to the significance of this small town. The historic library at Allensworth State Park has been restored and is open to the public for tours. Allensworth is listed on the National Register of Historic Places and is a California Historic Park.

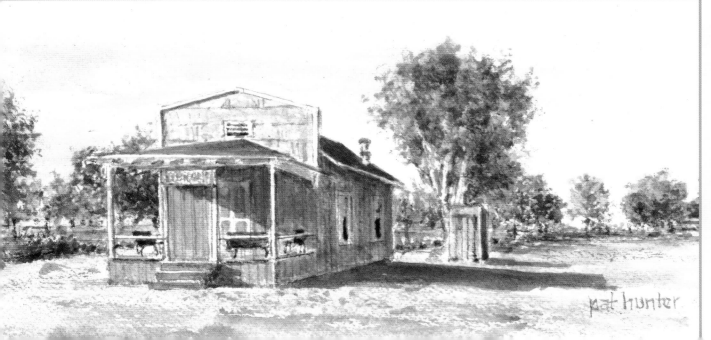

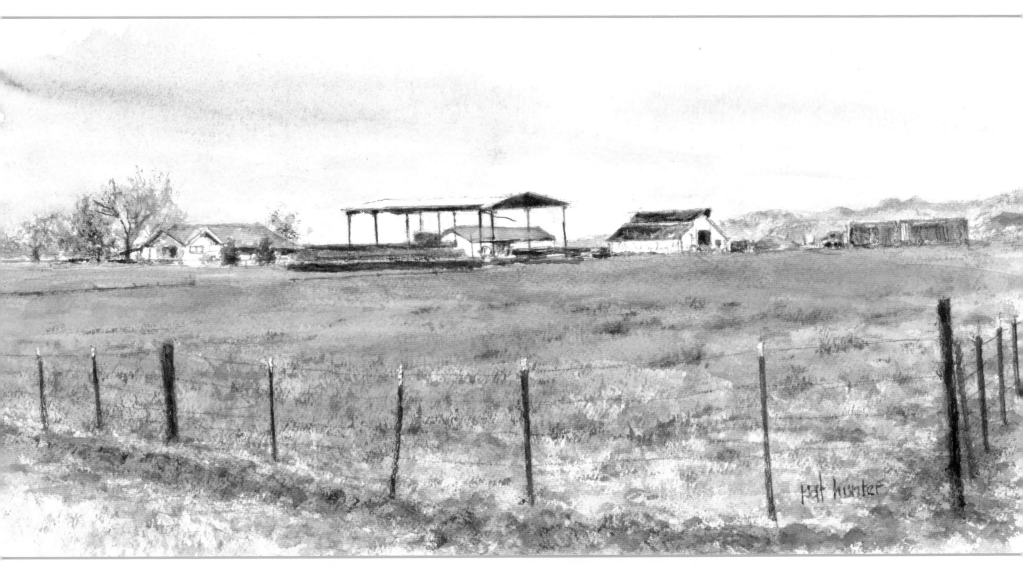

23 Strathmore Barn

This classic barn in Strathmore is typical for a family farm,
a rare remaining relic from an earlier era.

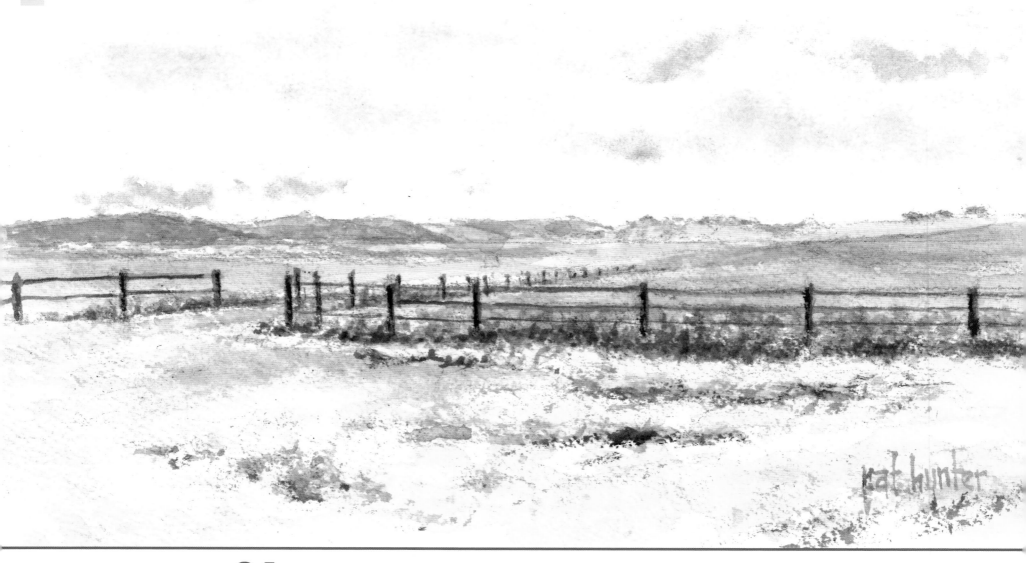

24 The Kettlemen Hills

The Kettlemen Hills of western Kings County are a low mountain range of the interior California Coastal Ranges. Approximately thirty miles long, they parallel the San Andreas Fault.

25 Parkfield Earthquake Center

The USGS Earthquake Monitoring Site located in Parkfield studies and records earthquake activity on the San Andreas Fault. Earthquake activity has frequently occurred in the same section of the fault line.

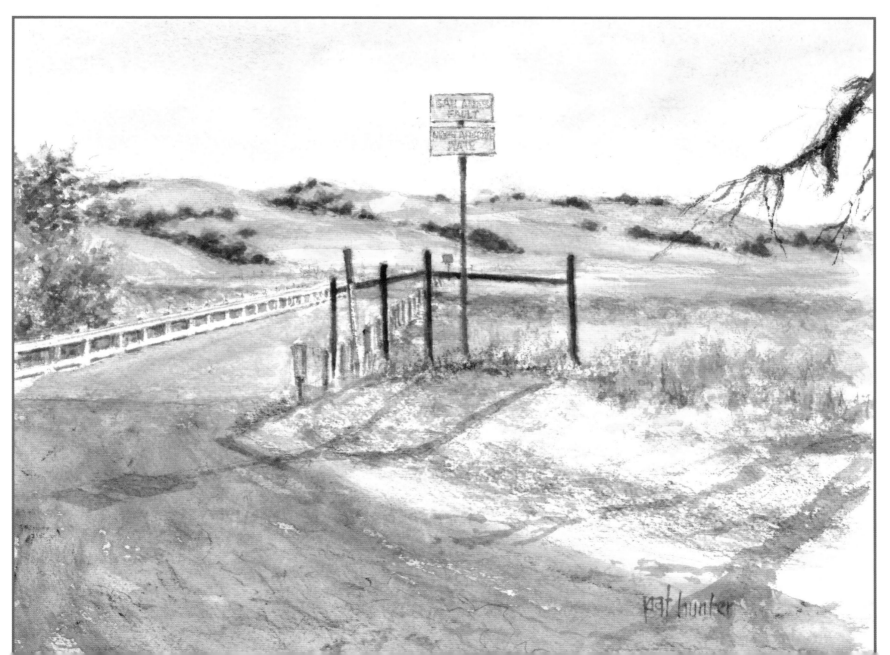

26 World Ag Expo Sign

The World Ag Expo Sign announces the location of what has become the world's largest annual outdoor agricultural exhibition. For over fifty years, the World Ag Expo has featured the latest innovations in farm products, as well as displays of antique farm equipment.

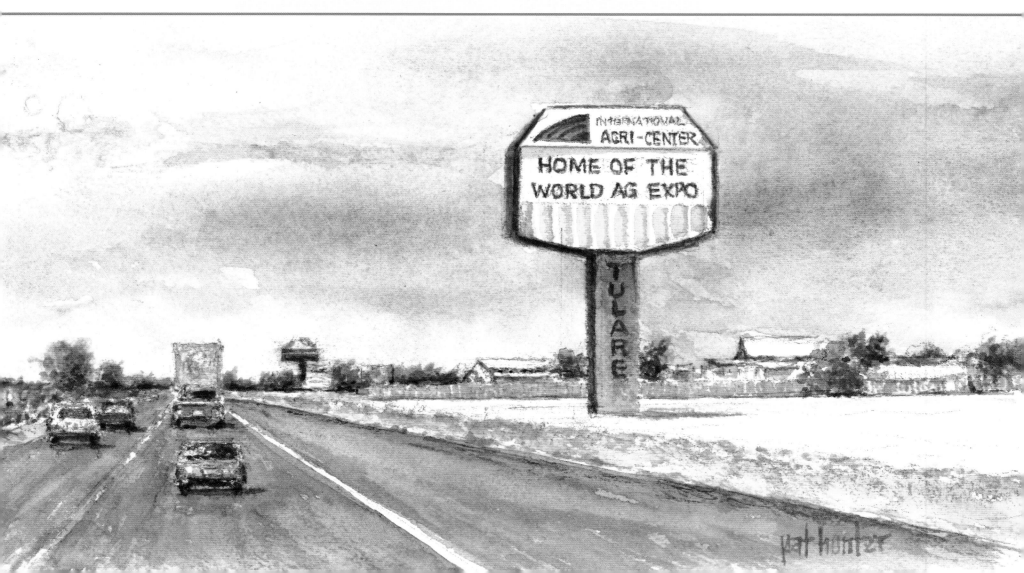

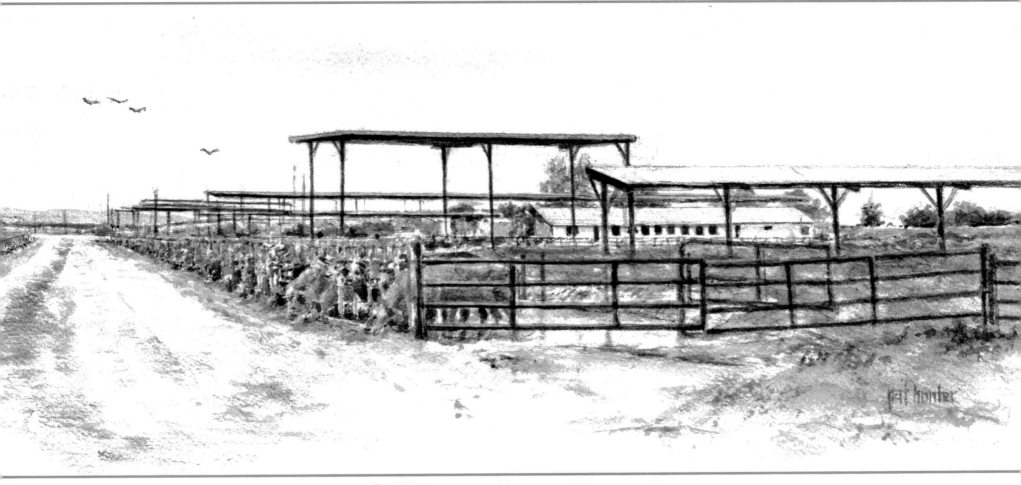

27 Dairy Landscape

Holding the reputation for having nearly more cows than people, Tulare County is one of the foremost producers of dairy products in the United States.

28 Success Lake and Dam

Constructed in 1961, Success Lake and Dam serves the water needs of both urban populations and agricultural lands along the Tule River. It also provides recreational opportunities for boating, water skiing, fishing, camping, picnicking, and hiking.

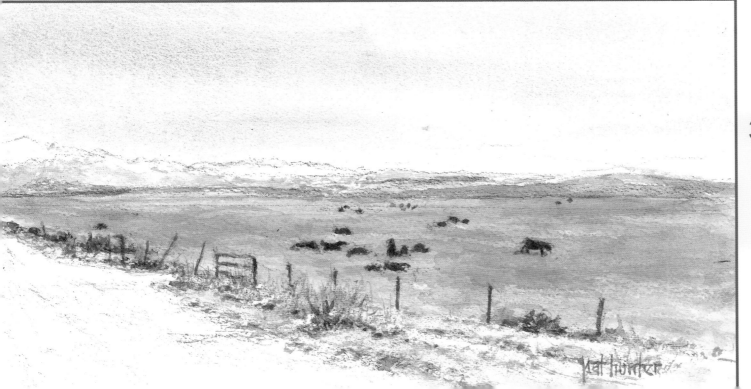

29 Exeter Orange Stand

The Mesa Verde Ranch's Big Orange, southeast of Fresno on State Highway 198, is one of only a few remaining Big Orange stands, which were once common in California.

30 Exeter Grazing Cows

The Exeter area's cattle ranching land offers a picturesque setting in a valley beneath snowcapped mountains of the Sierra Nevada range.

31 Lake Kaweah Reservoir

Lake Kaweah is a reservoir formed by the Terminus Dam on the Kaweah River. Its primary purpose is flood control, so the lake is often kept at a low level, or empty, with water released heavily throughout the winter. Houseboats nestle in the cove, creating a community of people living on the water.

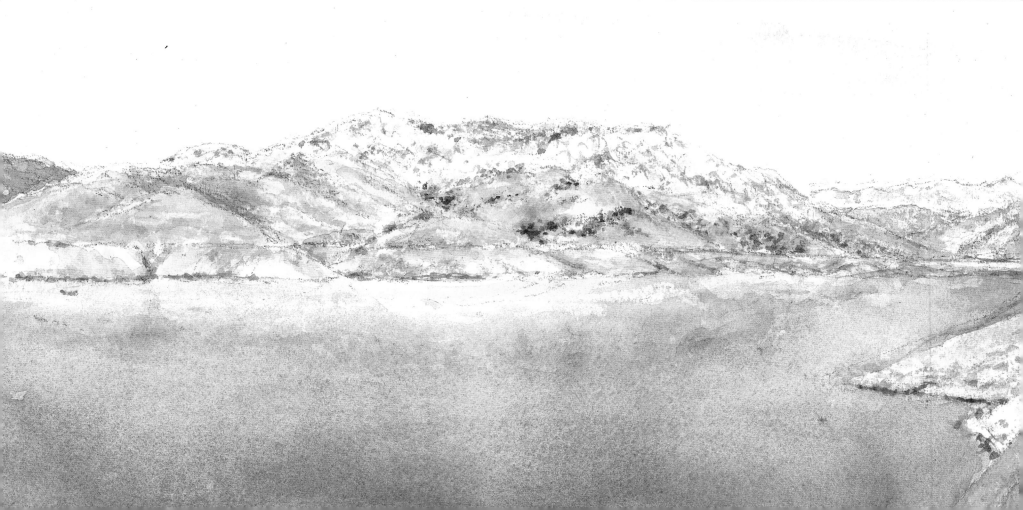

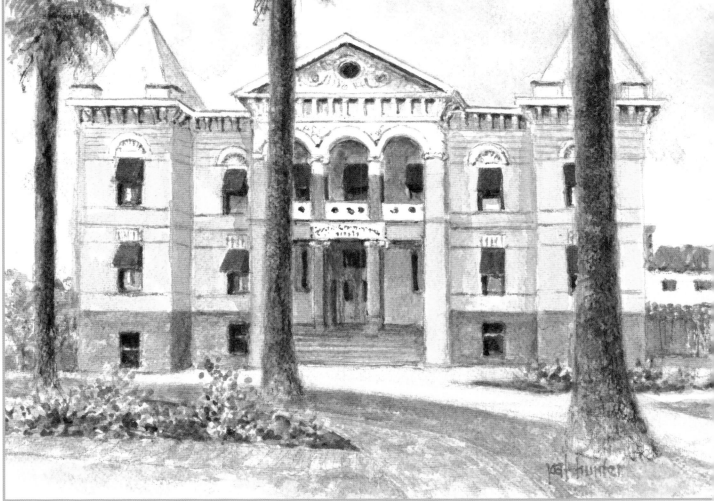

32 The Hanford Courthouse

The Hanford Courthouse is a classic building situated in a parklike setting in downtown Hanford. Constructed in 1896, it features mixed architectural styles. Expanded in 1914, the courthouse served the community of Hanford until 1976. It was remodeled in 1980 to accommodate office buildings and small businesses. It is listed on the National Register of Historic Places.

33 Superior Dairy in Hanford

A popular ice cream parlor in the Central
Valley since 1929, Superior Dairy serves
large scoops of homemade ice cream in
banana splits, sundaes, and cones.

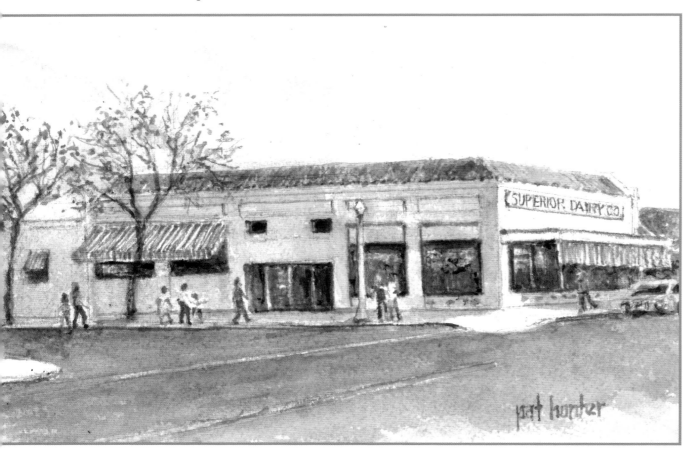

34 Kings County Farm

Hanford boasts more than
100 dairy farm companies.

pat hunter

35 Hanford Agriculture
Hanford's field crops of wheat and alfalfa support the dairy industry.

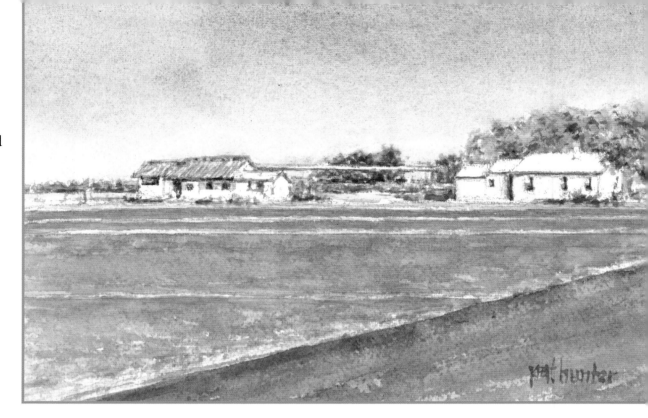

36 Cotton Fields in Lemoore/Avenal
After harvest, cotton modules are loaded onto trucks in the Lemoore/Avenal area.

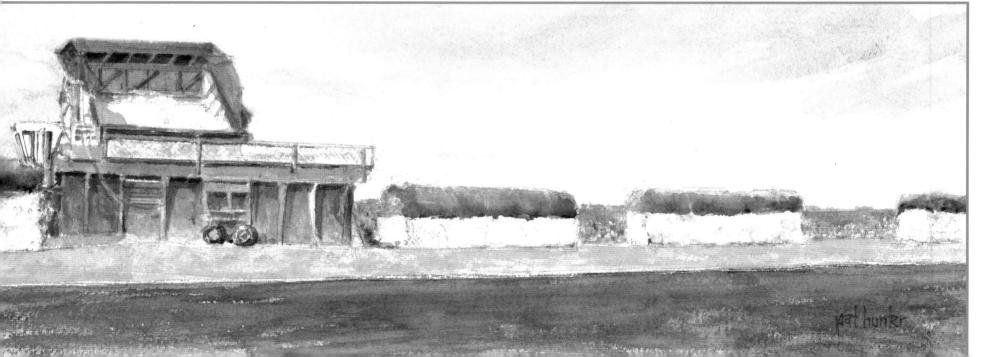

37 Coalinga Oil Fields

Numerous oil pumps are visible on the barren
landscape along Highway 33 northeast of Coalinga.

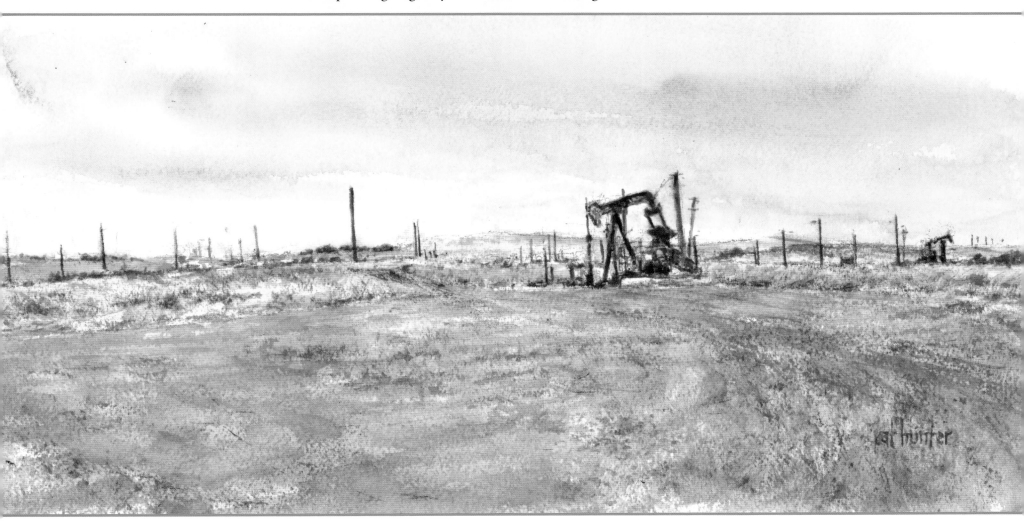

38 Huron Field

During the winter months, farmers plow and enrich the soil in
preparation for spring planting in Huron, a small city in Fresno County.

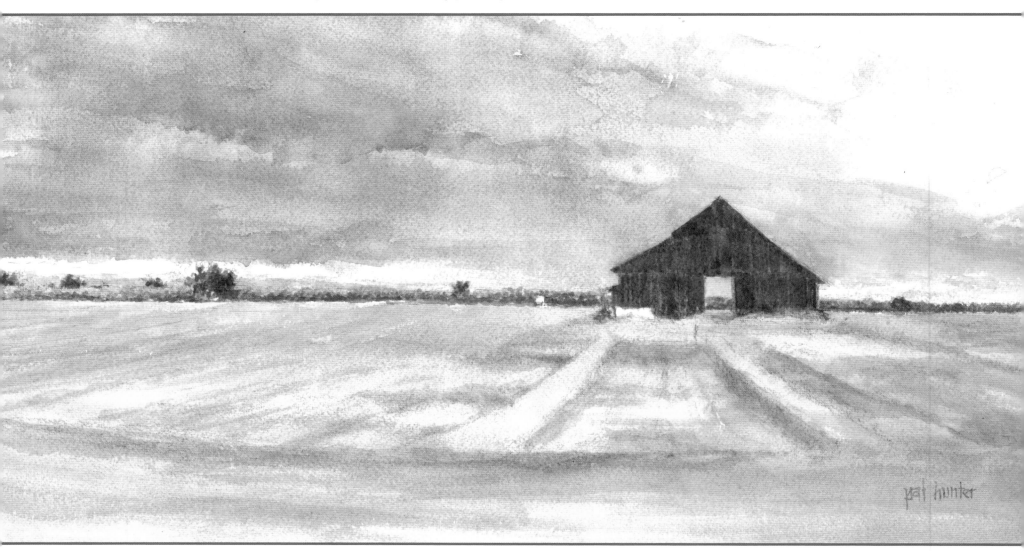

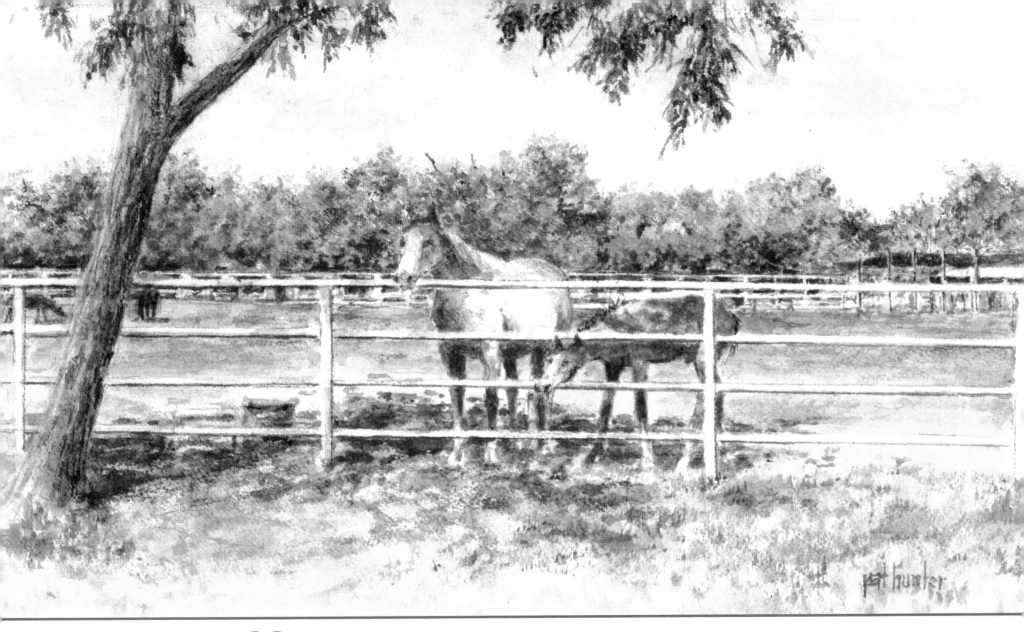

39 **The Harris Ranch Horse Division**

The Harris Ranch Horse Division is home to award-winning race horses,
including the most famous and lucrative prodigy California Chrome,
who was the "earningest" horse in the world in his prime.

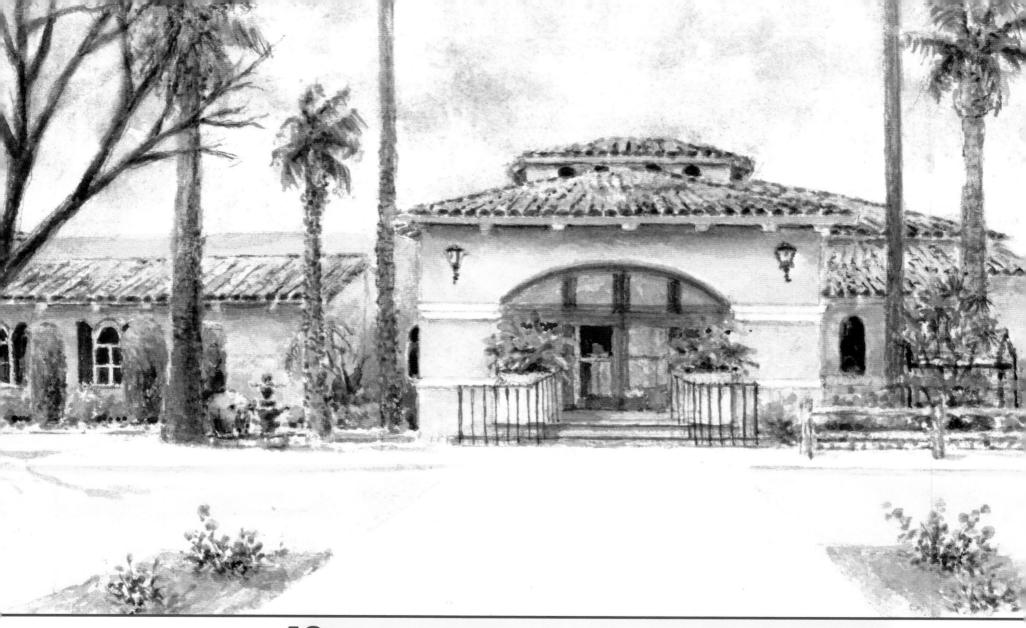

40 **Harris Ranch Restaurant**

Harris Ranch boasts a reputation for its hacienda-style resort. Located in Coalinga, with Interstate 5 minutes away, the Harris Ranch restaurant and hotel are popular venues for both weary travelers seeking rest and hungry drivers passing through.

41 **Priest Valley Tavern**
In its heyday, the Priest Valley Tavern—tucked into scenic rural countryside on Highway 198 between Coalinga and east of the Diablo Mountain Range in Central California—welcomed visitors to a cool drink and refreshment.

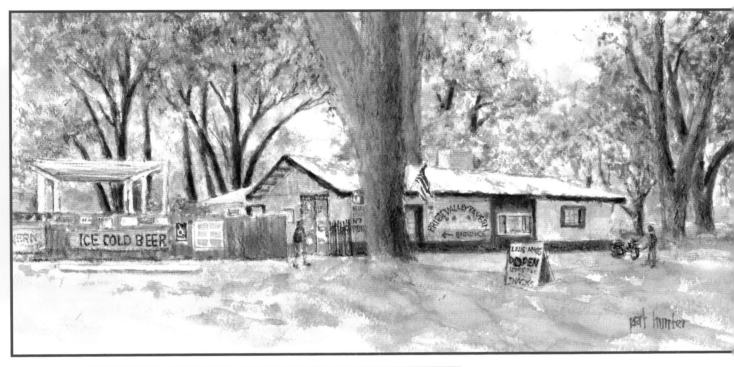

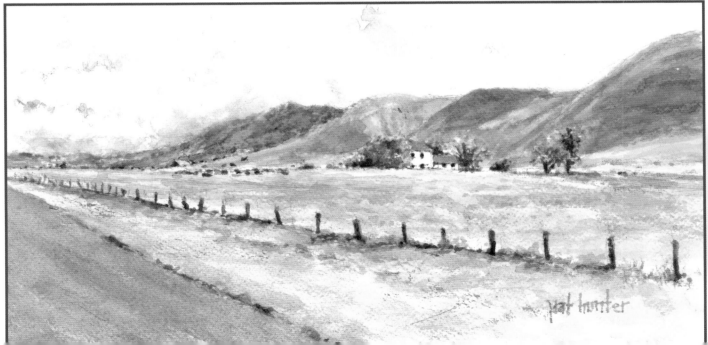

42 **Priest Valley Farm**
An isolated farmhouse on Highway 198 is seen from the distance in a valley primed for cattle grazing.

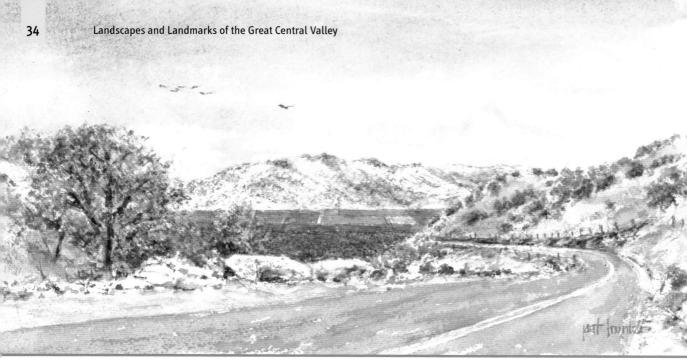

43 Orosi Citrus Field

Often called "California Land of the Oranges," this Central Valley landscape showcases vast orchards between Orange Cove and Orosi.

44 The Orosi Canal

The canal in Orosi at the base of the foothills provides critical water supplies to the surrounding citrus orchards.

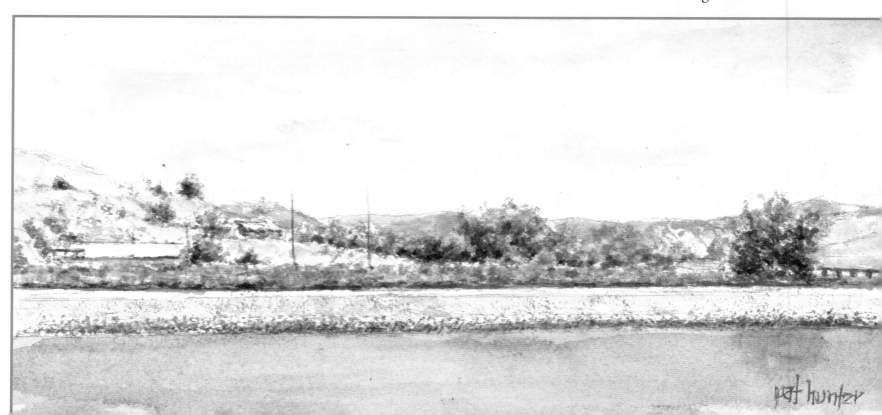

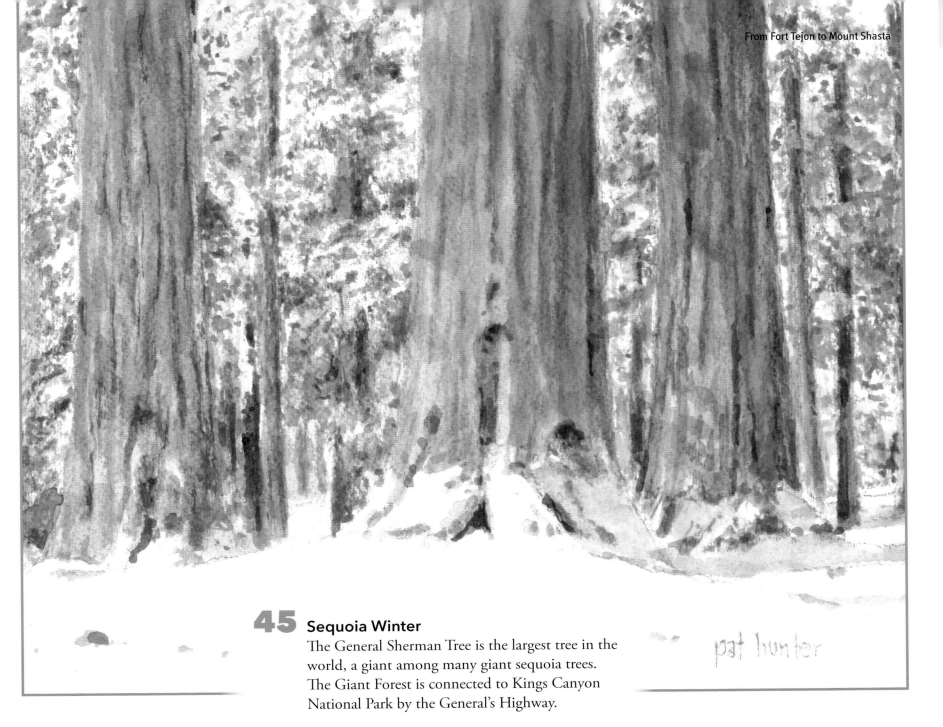

45 Sequoia Winter

The General Sherman Tree is the largest tree in the
world, a giant among many giant sequoia trees.
The Giant Forest is connected to Kings Canyon
National Park by the General's Highway.

pat hunter

46 Sequoia National Park Sign

Established on September 25, 1890, the Sequoia National Park in the southern Sierra Nevada mountain range east of Visalia is a designated American National Park.

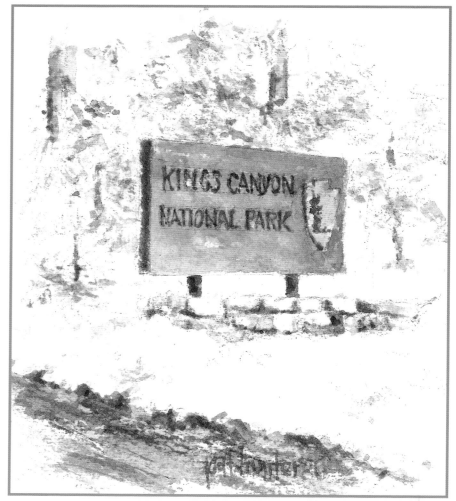

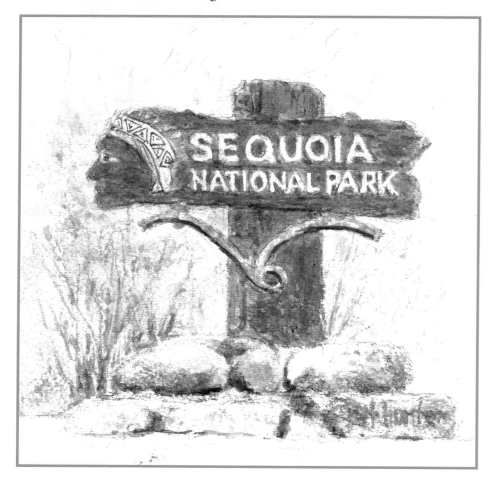

47 Kings Canyon Sign

Kings Canyon National Park in the Southern Sierra Nevada offers accommodations such as the Wuksachi Lodge, the John Muir Lodge, and the Grant Grove Cabins. All are near hiking and sightseeing trails that wander through the towering redwoods. Kings Canyon is home to Hume Lake Christian Camp, offering camps to children and adults alike.

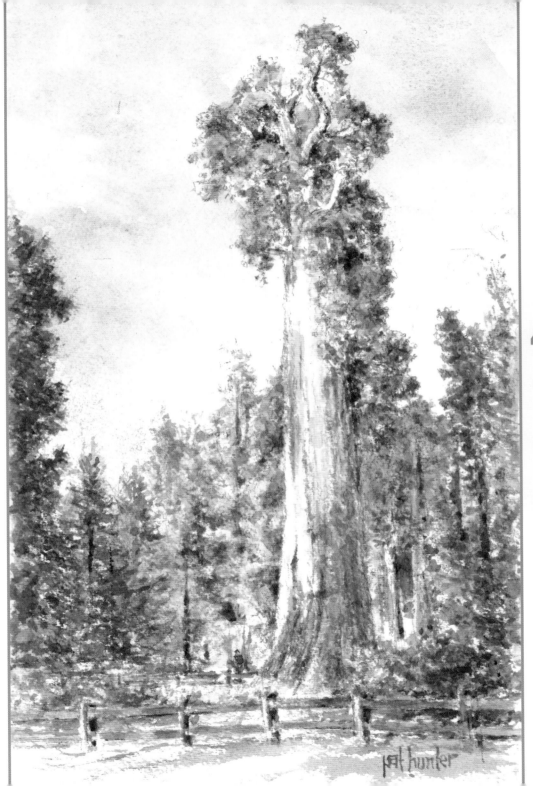

48 General Grant Tree

Kings Canyon National Park is home to the General Grant Tree in the General Grant Grove, the second largest tree in the world. The General Grant tree is well known as the nation's Christmas tree.

49 Reedley Opera House

Built in 1903, the Janzen Opera House, affectionately referred to as the Reedley Opera House, is home to Reedley's River City Theatre Company and is used for cultural public events as well as private events.

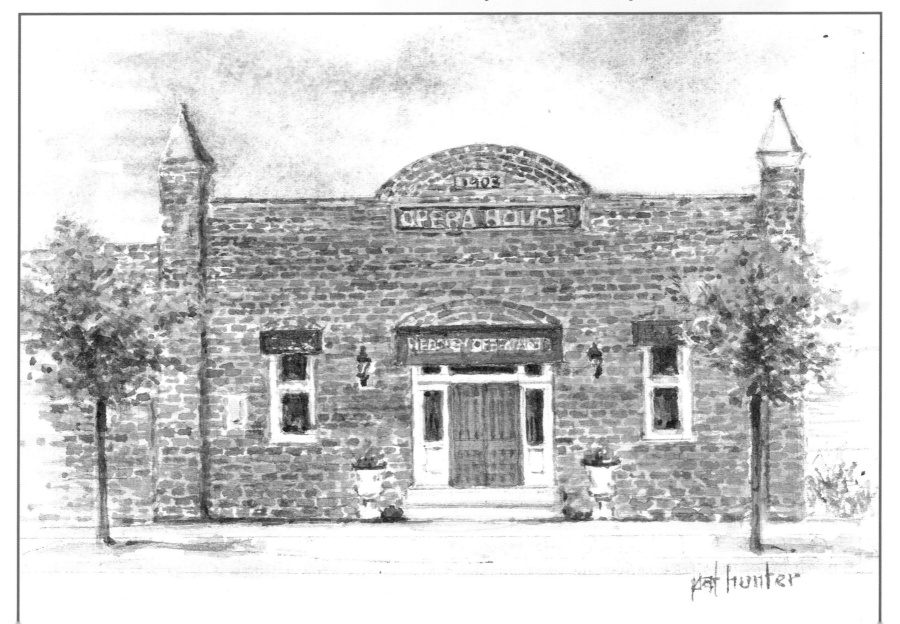

50 **Fowler Vineyards**
A large turn-of-the-century farm house surrounded
by vineyards reflects a bygone era.

51 Sanger Spring

Profuse in early spring, almond blossoms add to the popular and colorful Blossom Trail of the Central Valley.

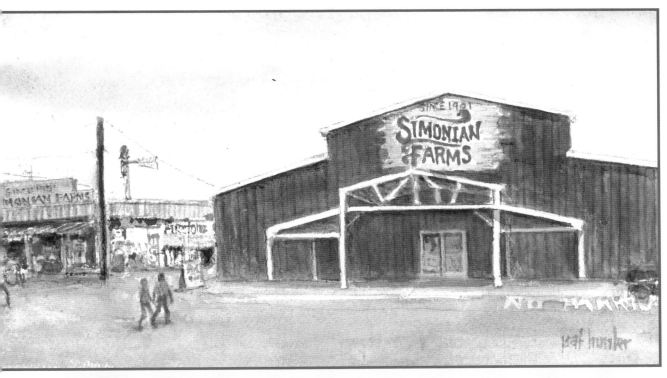

52 Simonian Farms

A more-than-typical produce stand, Simonian Farms in Sanger features "Old Town," a museum-quality display of antique farm equipment and other memorabilia. Simonian's is renowned for its produce, a large assortment of fruits, grains, and honey.

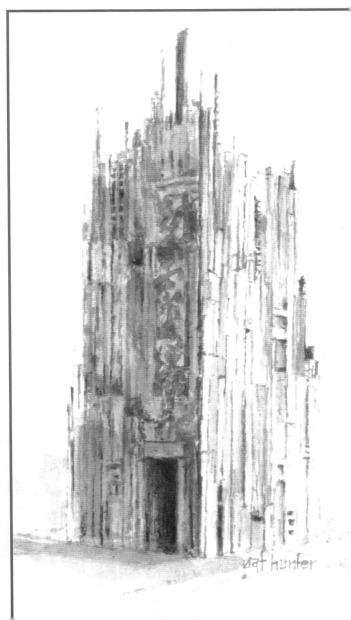

53 Simonian's Tower

Positioned on a corner surrounded by orchards and vineyards, Simonian Farms is a destination location. In honor of their Japanese friends, the Simonian family erected a large structure called "Soul Consoling Tower," constructed from wood taken from a Japanese internment camp on the grounds of their farm.

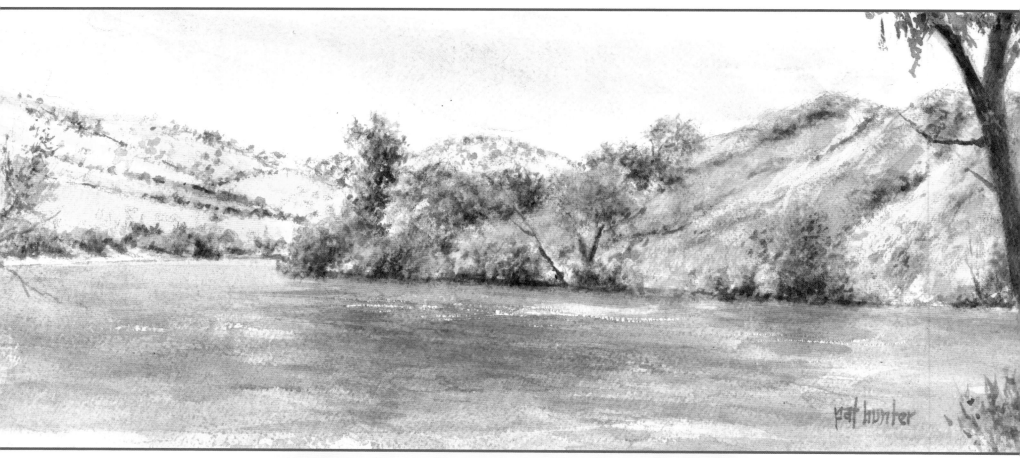

54 Kings River

The scenic Kings River flows from the Sierra Nevada Mountains to the San Joaquin Valley. This view is near the site of the former Doyal's General Store on Trimmer Springs Road.

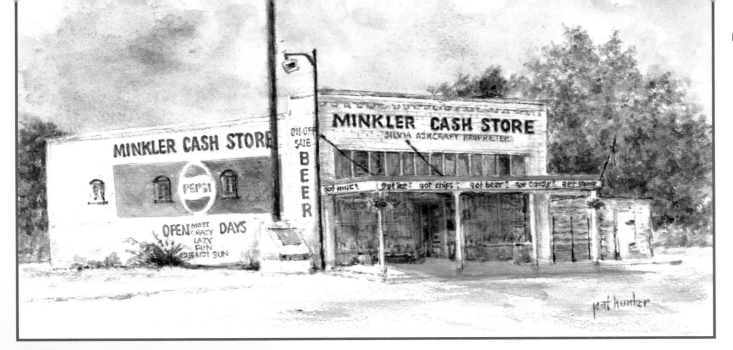

55 Minkler Store

Named for pioneer farmer Charles O. Minkler, the town of Minkler is located east-southeast of Centerville. Highway 180 now bypasses what remains of Minkler. An iconic general merchandise store endures. An eclectic collection of items line the shelves and walls of the old store, which contains an antique bar dating back to the early 20th century.

56 Foothills and Canal East of Minkler

Near the foothills east of Minkler, a meandering canal transports water to farm land.

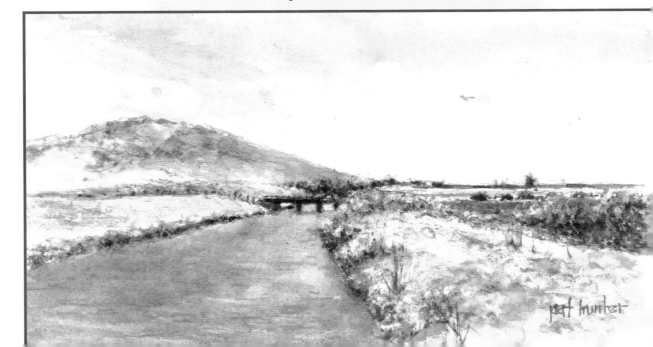

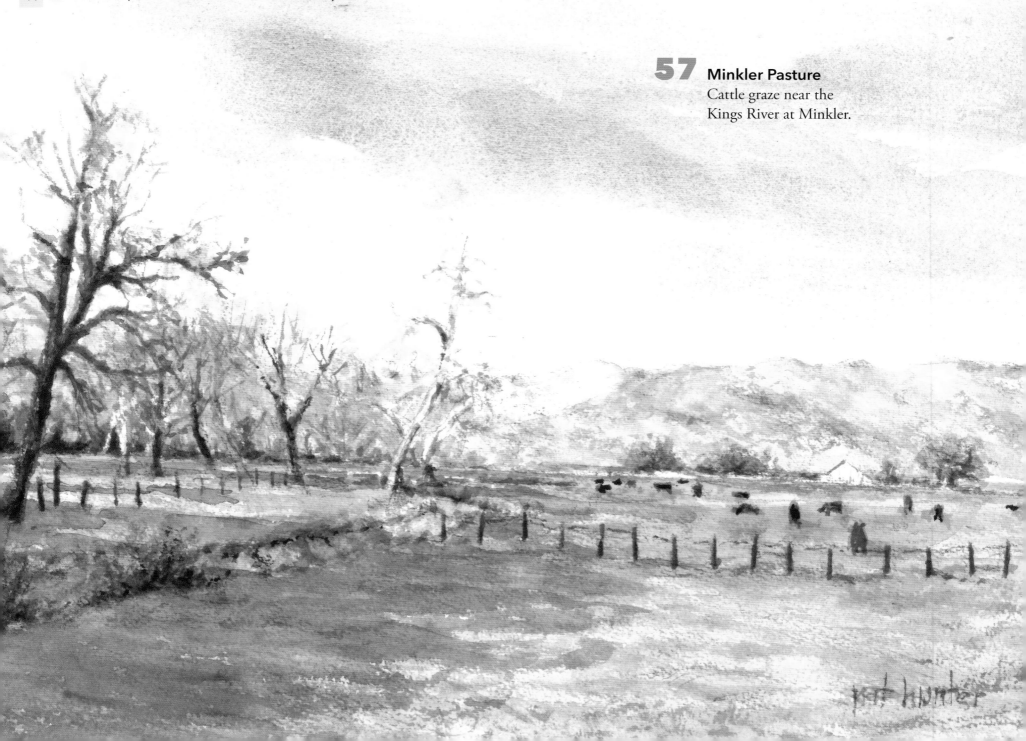

57 **Minkler Pasture**
Cattle graze near the
Kings River at Minkler.

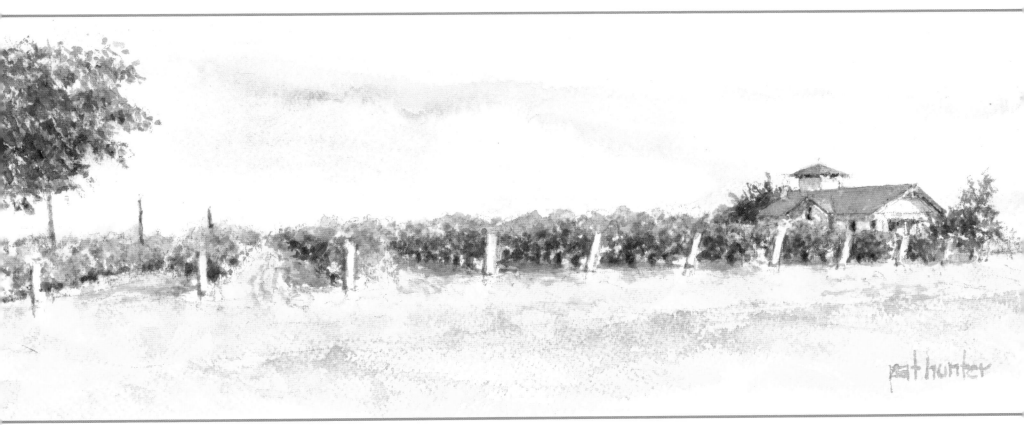

58 Valley Farm
Grape vines surround a family farm in the Central Valley.

59 **Spring Planting**
The agricultural fields stretching to the foothills showcase a variety of crops in various stages of growth.

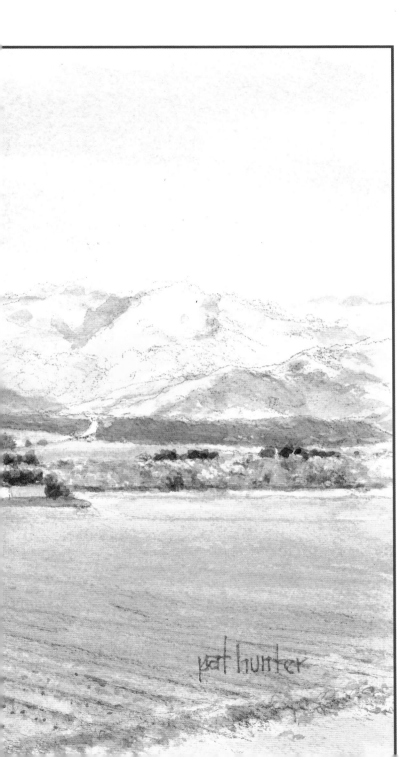

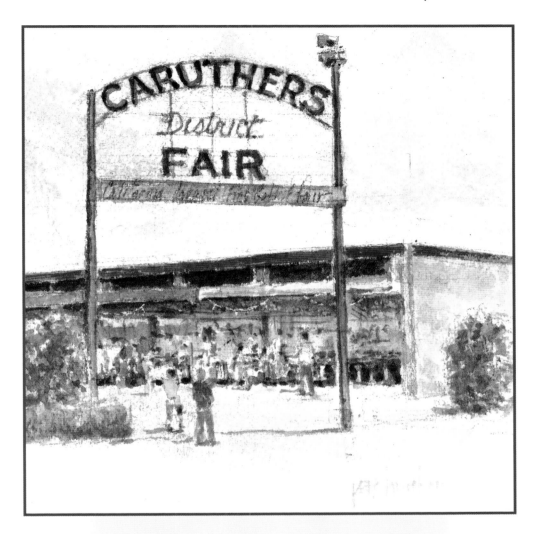

60 Caruthers County Fair Sign

Located approximately fifteen miles from Fresno, Caruther's first post office opened in 1891. The Caruthers District Fair, established in 1923, draws folks from nearby areas to this small farming community.

61 Forestiere Gardens

"To make something with a lot of money, that is easy; but to make something out of nothing—now that is really something." With that thought, Sicilian immigrant Baldassare Forestiere began his forty-year-long obsession in the early 1900s to build an underground home to be a cool refuge from the scorching San Joaquin Valley summer heat. The vast maze of tunnels and rooms spanning more than ten acres, and a few rooms hollowed out at a depth of twenty-five feet underground, are open for tours.

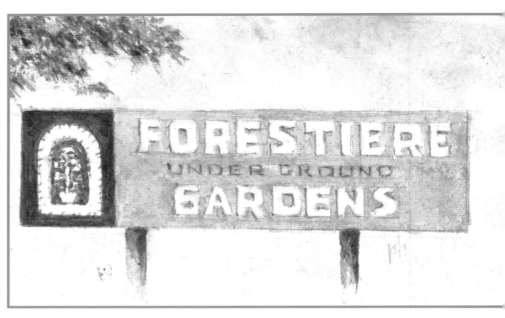

62 Fresno Chaffee Zoo

The Fresno Chaffee Zoo spans thirty-nine acres in Fresno's Roeding Park and is home to more than 190 animal species. The zoo opened in 1929 as the Roeding Park Zoo, but the name changed in 1985 in honor of the zoo's first director, Paul S. Chaffee.

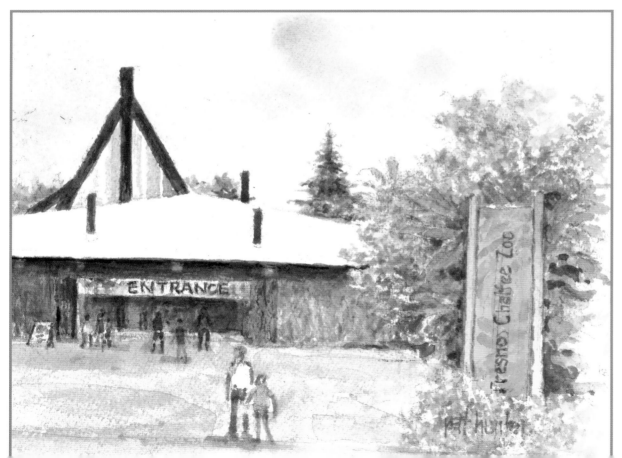

63 Kearney Mansion

The stately Kearney Mansion was constructed in 1903 for M. Theo Kearney, who was credited with creating the Fruit Vale Estates, an early land development idea that helped transform the Central Valley into an agricultural landscape.

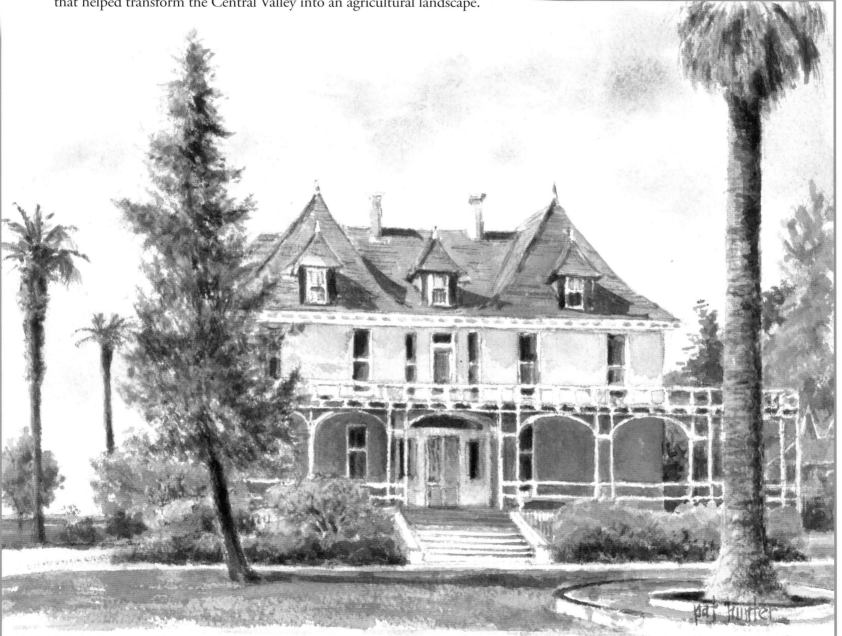

64 **Kearney Colony Farm**
Kearney developed the Colony Farm in the early 1900s. The
image is of the working division of Chateau Fresno Park.

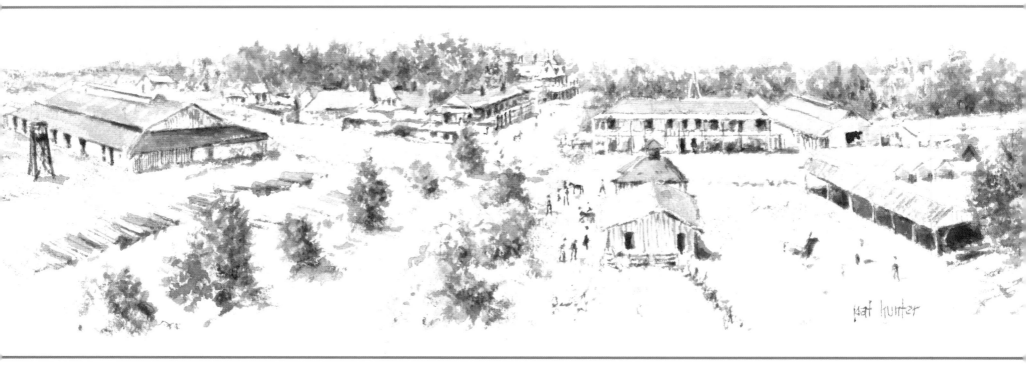

65 **The Big Fresno Fair** (facing page)
The Big Fresno Fair, established in 1884, continues to showcase the agricultural
bounty of Fresno County, featuring livestock shows, horse racing, exhibits, and
educational and musical programs. The site was used in 1942 as a detention center
for Japanese held before being transported to internment camps. Of note, the
award-winning Big Fresno Fair Museum displays the history of the Fresno Fair,
and the Fresno County Historical Museum showcases the extensive history of
Fresno County, offering two floors filled with numerous exhibits.

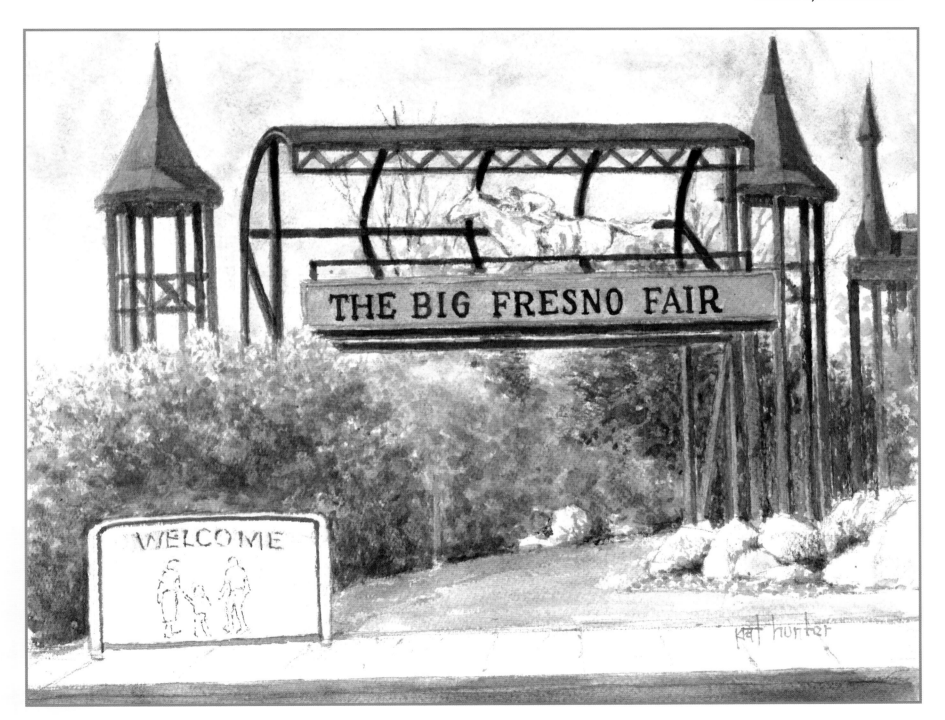

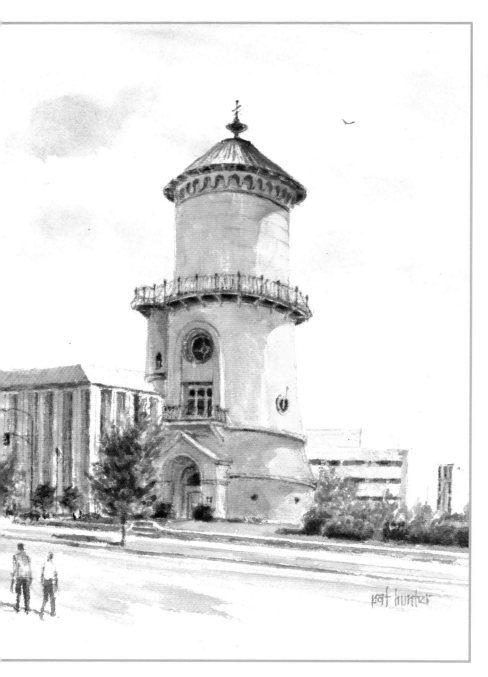

66 Fresno Water Tower

The Fresno Water Tower, designed by George Washington Maher in 1891, remained the main source of water for the city of Fresno until 1963. The water tower stands one hundred feet high and had a storage capacity of 250,000 gallons, dispersed among various containers within the round, brick, Romanesque structure. The water tower is listed on the National Register of Historic Places.

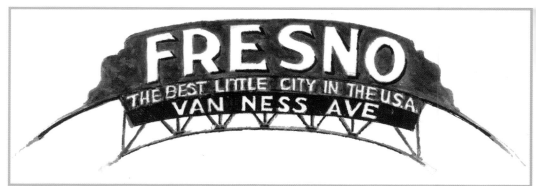

67 Best Little City Sign

"The Best Little City in the U.S.A," reads a steel welcome archway over the Van Ness entrance into the city. The sign was built in 1929 and restored with neon lighting in 1980. The Best Little City in the U. S. A. archway is listed on the Local Register of Historic Resources.

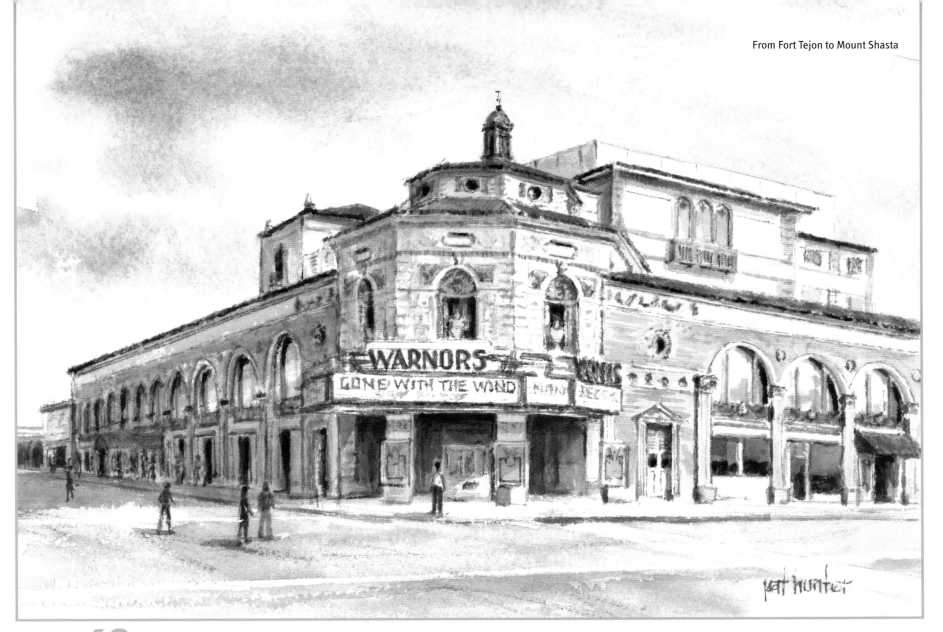

68 The Pantages/Warnors Theater

The Pantages/Warnors theater, located on Fulton Street in downtown Fresno and long considered to be the "Jewel of Fresno," was built by Alexander Pantages and designed by B. Marcus Priteca in 1928 for vaudeville. The theater now operates as the Warnors Center for the Performing Arts under the direction of the Caglia family. The Warnor's Theater is listed on the National Register of Historic Places and the Local Official Register of Historic Resources.

69 Tower Theater

The Tower Theater, built in 1939 and designed by S. Charles Lee in the Streamline Moderne architectural style, seats 750 people. The Tower Theater has long been recognized for its historical ambiance and is listed on the National Register of Historic Places, the California Register of Historical Resources, and the City of Fresno Local Official Register of Historic Resources.

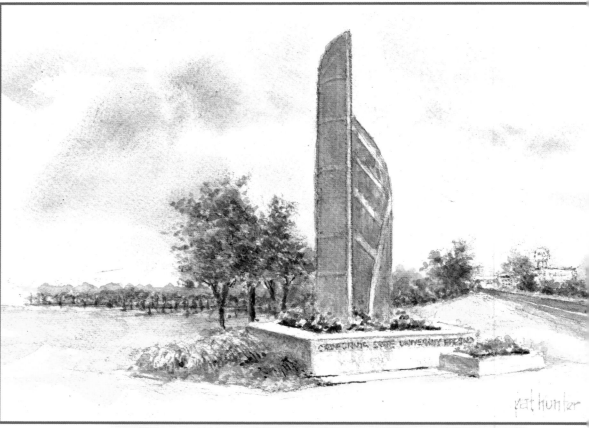

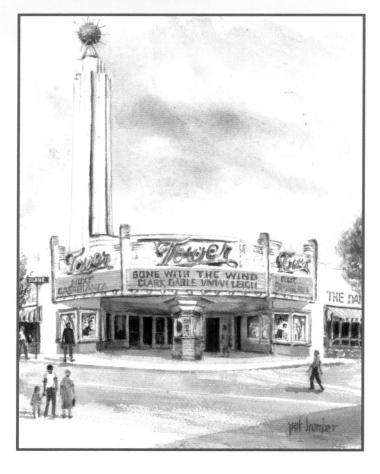

70 California State University Fresno

California State University Fresno is highly rated for its award-winning wines and produce. The Jordan College of Agricultural Sciences and Technology offers seven departments in the areas of agriculture, including the 1,000-acre on-campus University Agricultural Laboratory. The college supports a number of related agricultural businesses, including dairy, produce, and equestrian programs, besides the vintner program.

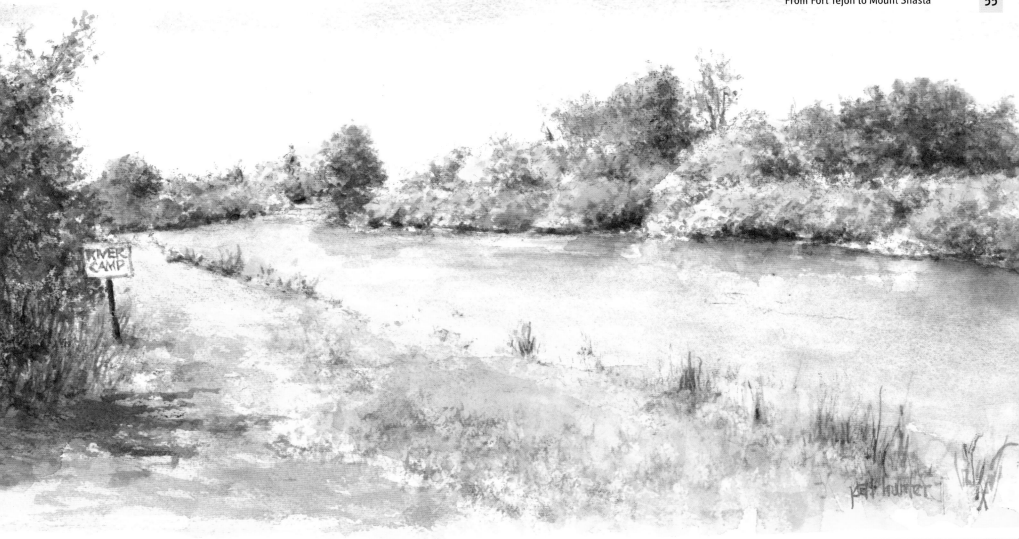

71 San Joaquin River Camp at Scout Island

River Camp at Scout Island on the San Joaquin River is a nature camp for children entering first grade through eighth grade. River Camp is one of many programs offered under the auspices of the San Joaquin River Parkway and Conservation Trust, Inc. Founded by Coke Hallowell, the mission of the conservancy is to preserve and conserve the San Joaquin River lands and to provide educational awareness about them.

72 Takahashi Fruit Stand

The well-known Takahashi family farmed in the Central Valley since the early 1900s, and for several years operated a small, popular produce stand, first in Clovis and then at locations in different rural areas. Takahashi Fruit Stand is now located at Copper Avenue and Academy Avenue in Clovis. With Fresno County now the garlic capital of the United States, look for this item at the Takahashi Fruit Stand.

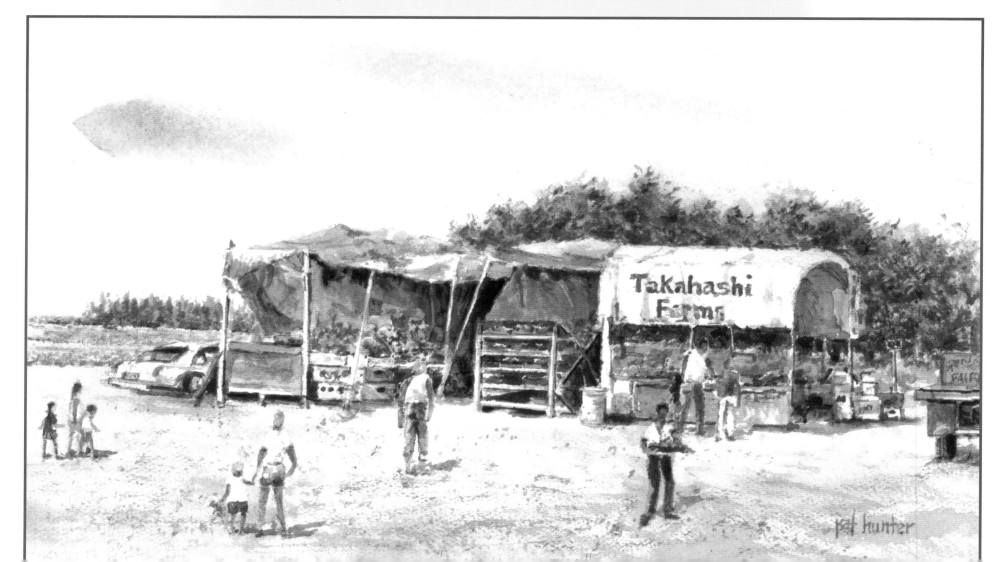

73 Fresno County Agscape West of Highway 99

This farm and tank house offer a nostalgic image of growing
row crops on a family farm.

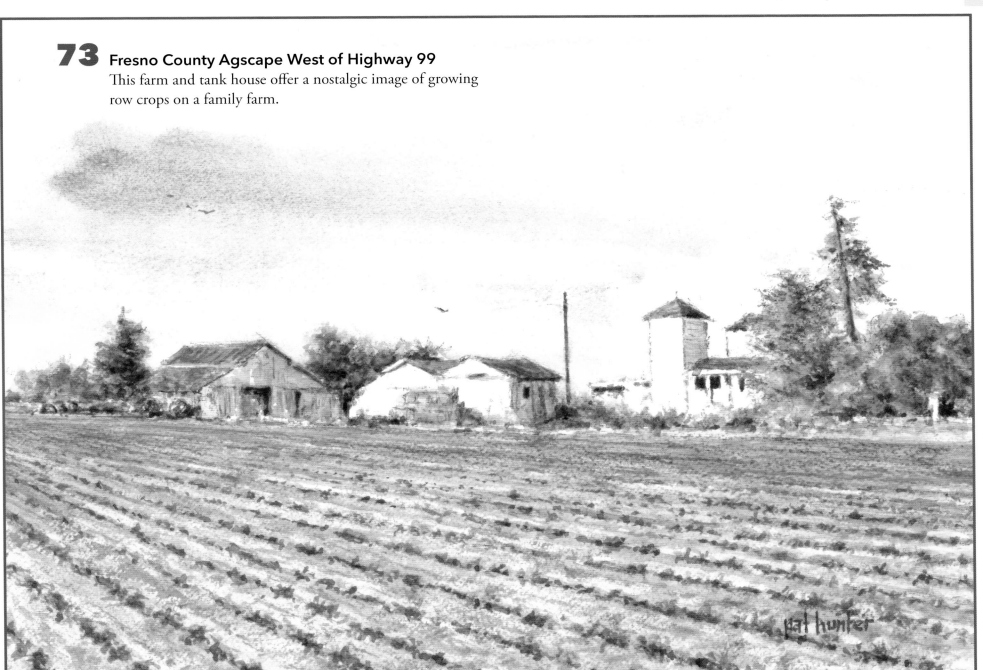

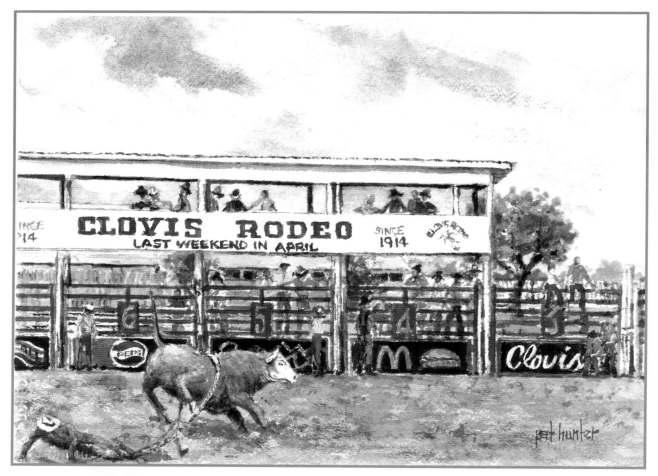

74 Clovis Rodeo

The "Clovis—A Way of Life" slogan celebrates a Western cowboy culture made most apparent during the annual Clovis Rodeo, which draws bull riders and competitors from across the nation.

75 Clovis Avenue

The main street of the community of Clovis offers an eclectic mix of antique stores, modern businesses, and eateries. A large iconic sign across the street states, "Clovis: Gateway to the Sierras."

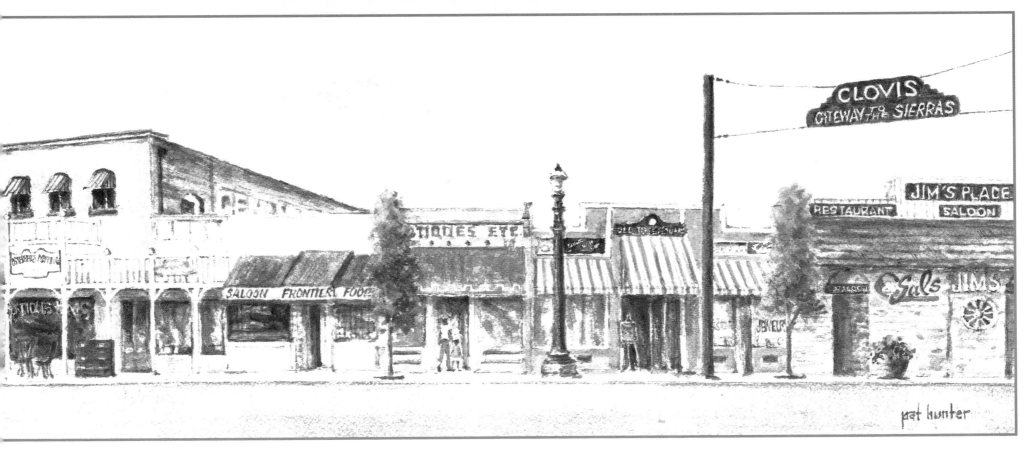

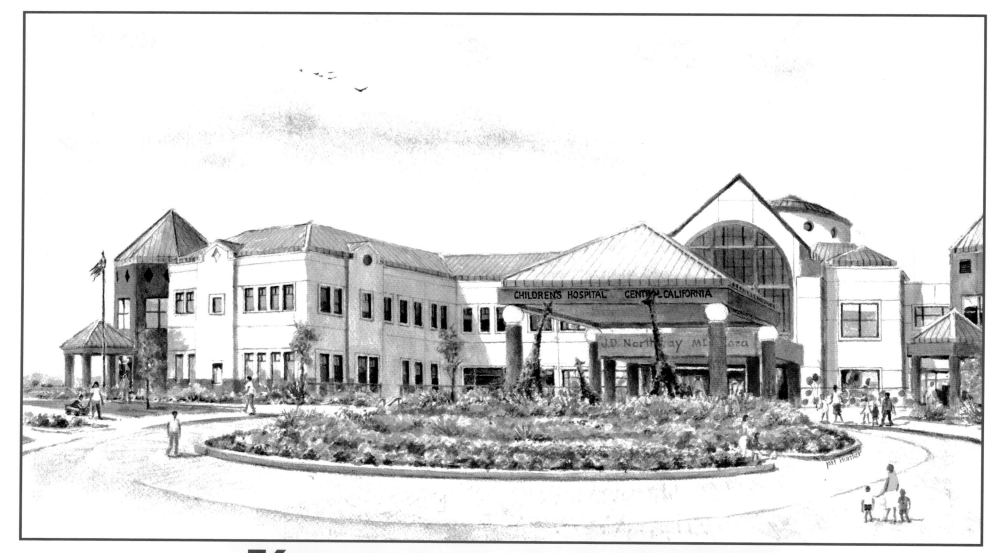

76 Valley Children's Hospital

Nationally ranked in four pediatric specialties, Valley Children's Hospital, formerly Children's Hospital Central California, is a children's general medical and surgical hospital located in rural Madera County. The hospital has also been awarded the Magnet Nursing Certification.

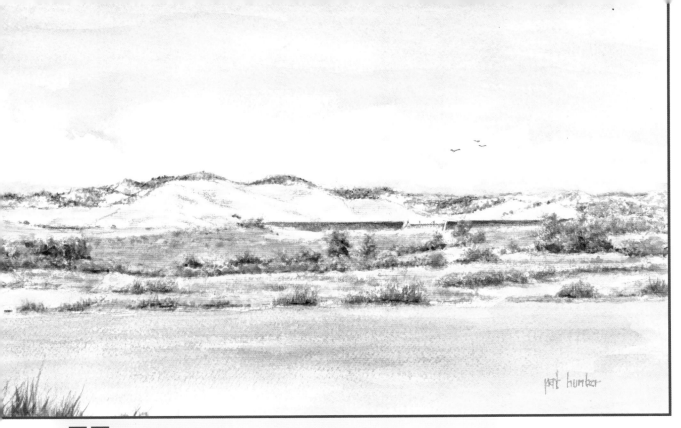

78 The Millerton Courthouse

The Millerton Courthouse, preserved and relocated, stands above the dam, the last remnant of Fresno County's first governmental seat.

77 Friant Dam

Friant Dam, a part of the U.S. Bureau of Reclamation, was built between 1937 and 1942 to provide irrigation water to the San Joaquin Valley. The dam impounds the San Joaquin River and the Millerton Lake reservoir, which when constructed drowned the small town of Millerton.

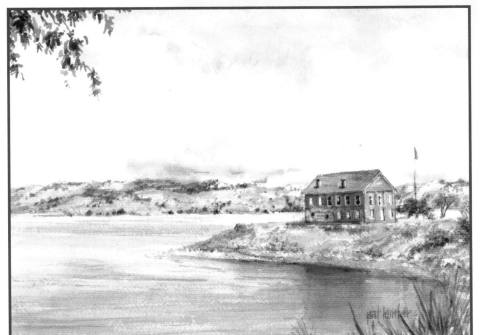

79 Shaver Lake

Shaver Lake is an artificial lake on Stevenson Creek in the Sierra National Forest. Small streams flow into the lake, as well as water from the underground tunnels of Southern California Edison's Big Creek Hydroelectric Project.

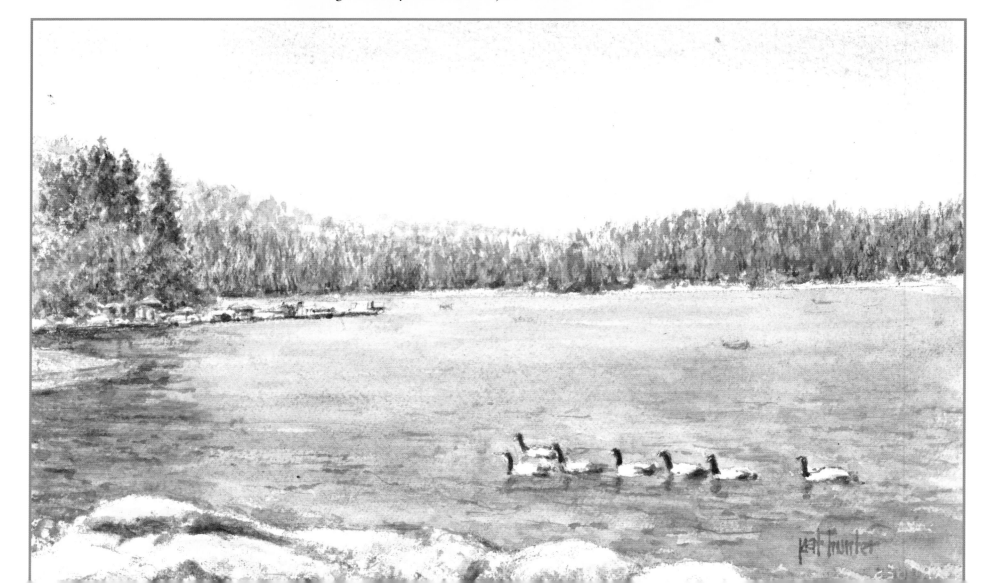

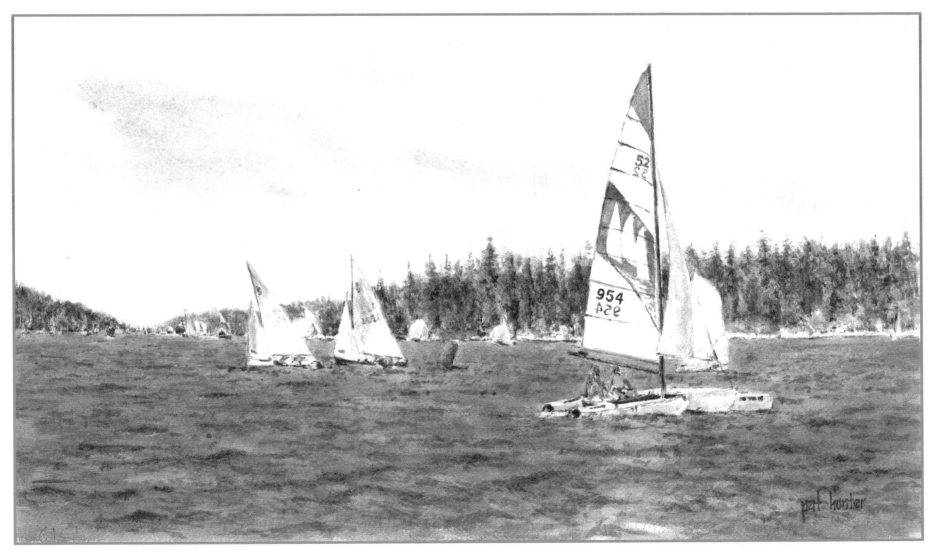

80 Huntington Lake

Huntington Lake, constructed in 1912, is located in Fresno County and receives its primary inflow from Big Creek, as well as from other smaller streams. Water also flows into the reservoir from Southern California Edison's Big Creek Hydroelectric Project. The lake is named for Henry Edwards Huntington, the railroad magnate who financed the early stages of the project.

81 Madera Courthouse

The Madera Courthouse, constructed in 1900 and located at 210 W. Yosemite Avenue in Madera, features granite gleaned from the Raymond quarry. The building was among the first constructed in Madera County. Deemed unsafe in 1953, a towering glass edifice was built to replace the old courthouse, which was later converted to a museum managed by the Madera County Historical Society.

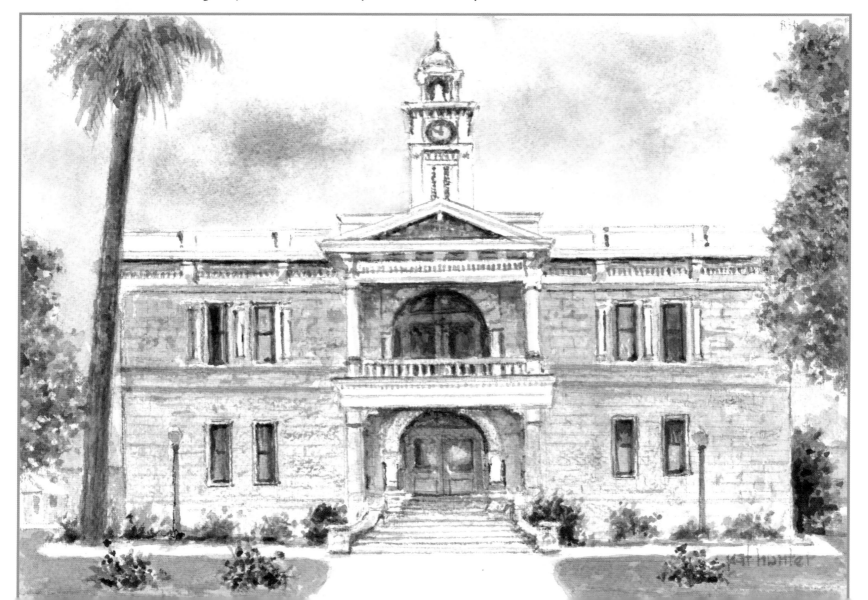

82 The Delta-Mendota Canal

The 117-mile Delta–Mendota Canal transports water from the Sacramento–San Joaquin Delta to the San Joaquin Valley in Central California.

83 Firebaugh Ag Scene

West of Fresno, this large dairy farm in Firebaugh contributes to the Valley's milk production.

84 Raymond

Raymond is a small community in the foothills of Madera County whose granite quarry supplied the stone for a number of substantial buildings in the Central Valley, most notably the 100-year-old Madera Courthouse. The first post office established the town in 1886 under the name of Wildcat Station; legend suggests the town was later renamed for Walter Raymond, who cut the ribbon for Raymond's dedication ceremony.

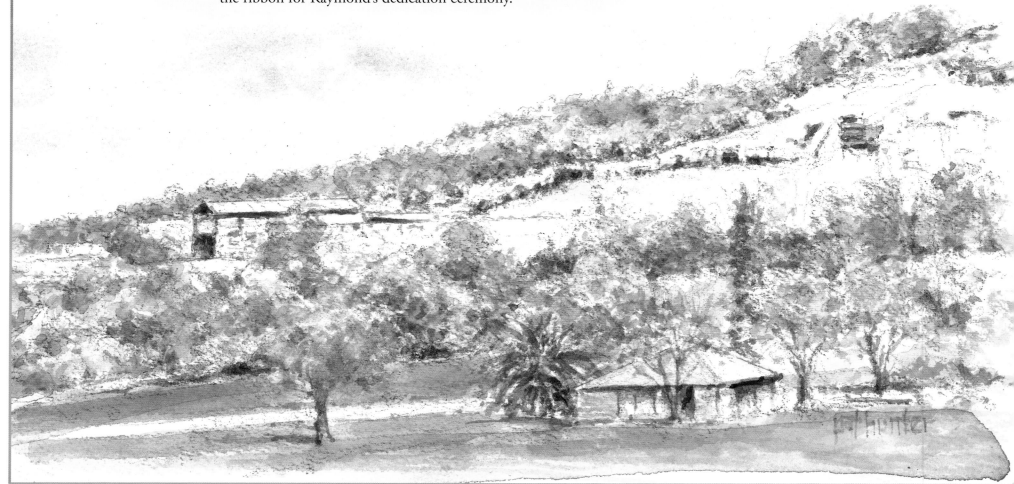

85 The Wassama Round House State Historic Park

The original Round House, also known as the dance house, is recorded in documents as early as 1858. The current Wassama Round House, located at 42877 Round House Road in Ahwahnee, was dedicated in 1985 and provides a meeting place for and preserves the culture of the Southern Sierra Miwok people. Built by Native American volunteers and park staff, it replicates the ancient traditional round houses.

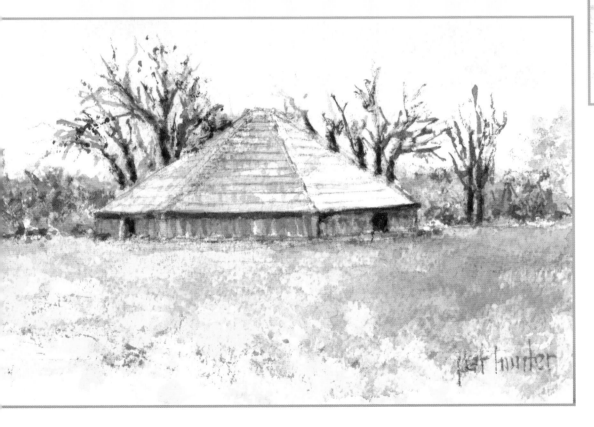

86 Grinding Rocks

The grinding rocks on the grounds are a reminder of the original inhabitants of this land. It is forbidden to walk on them. All natural and cultural features are protected by law and must not be removed or disturbed.

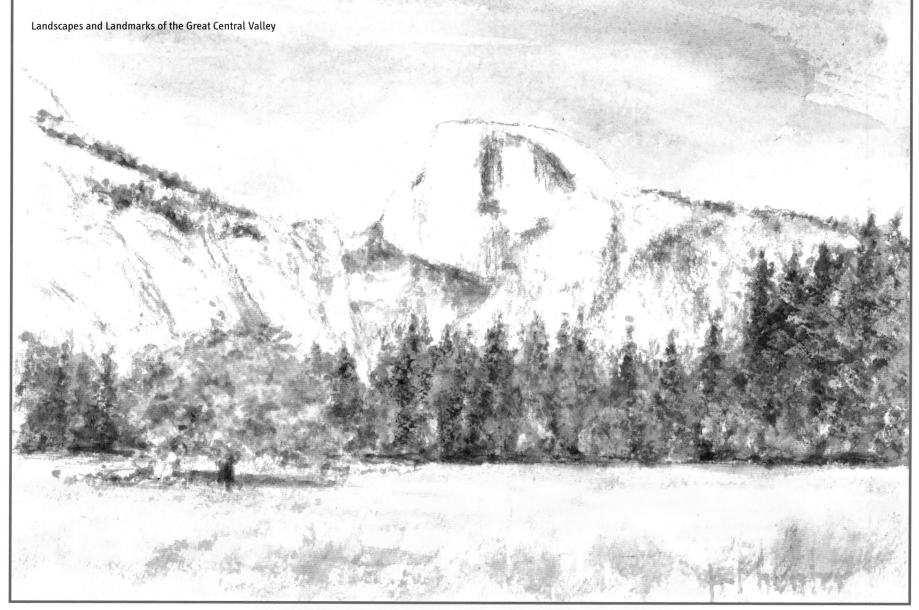

87 **Yosemite Half Dome**
Half Dome in Yosemite National Park in the
Sierra Nevada mountain range is one of the
most familiar granite landmarks in the world.

88 Yosemite Falls

Yosemite Falls in Yosemite National Park are the highest in the park. The tiered waterfalls drop a total of 2,425 feet.

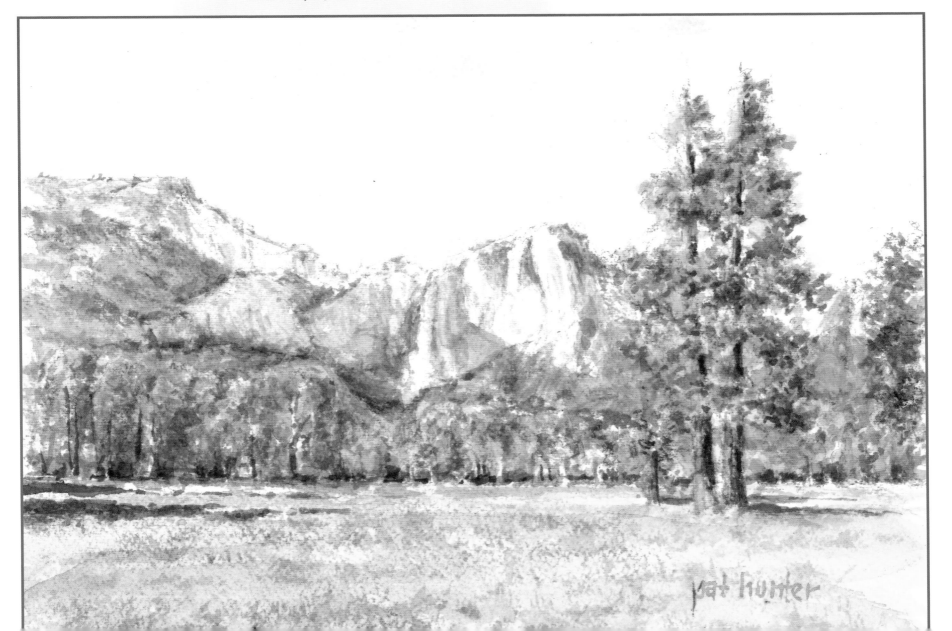

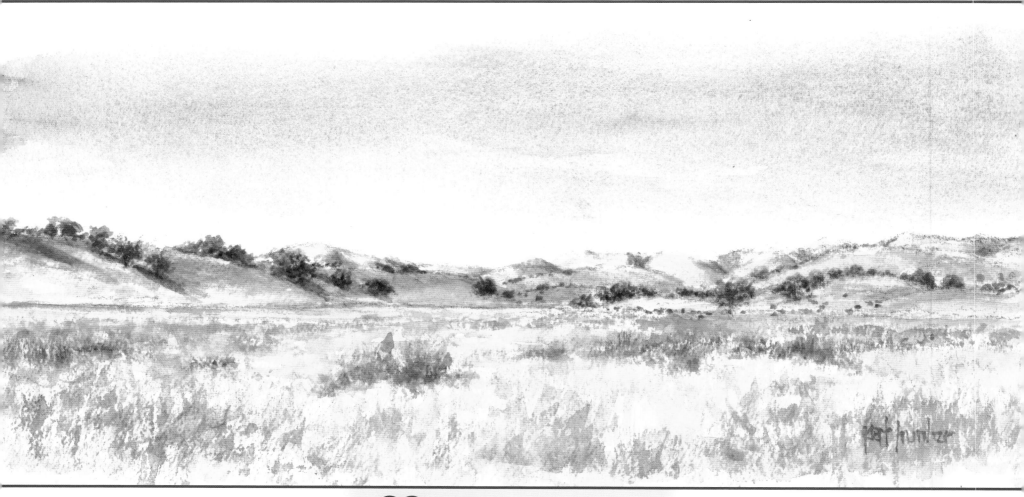

89 **Dairy Hills**
Cows graze in lush grasses in this
serene Fresno County valley.

90 Dos Palos Rice Co-op

The Dos Palos Rice Co-op is a privately owned company in Dos Palos California.

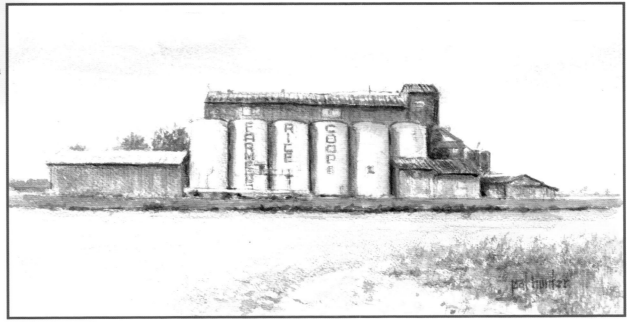

91 Chowchilla Auction

The livestock auction house in Chowchilla is located opposite the gates to the Chowchilla Fairgrounds.

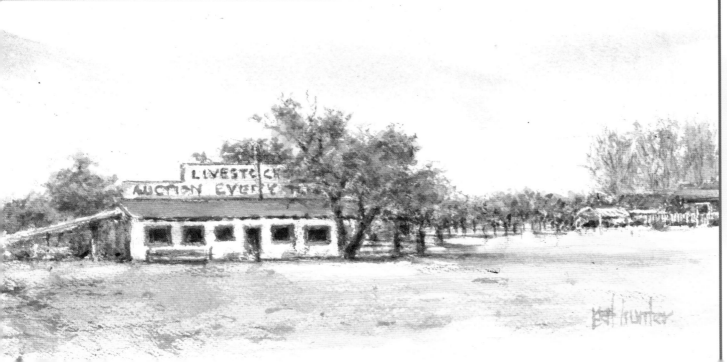

92 Grain Silos

The large grain silos on Highway 152 are used as storage for grain or other bulk products after harvesting.

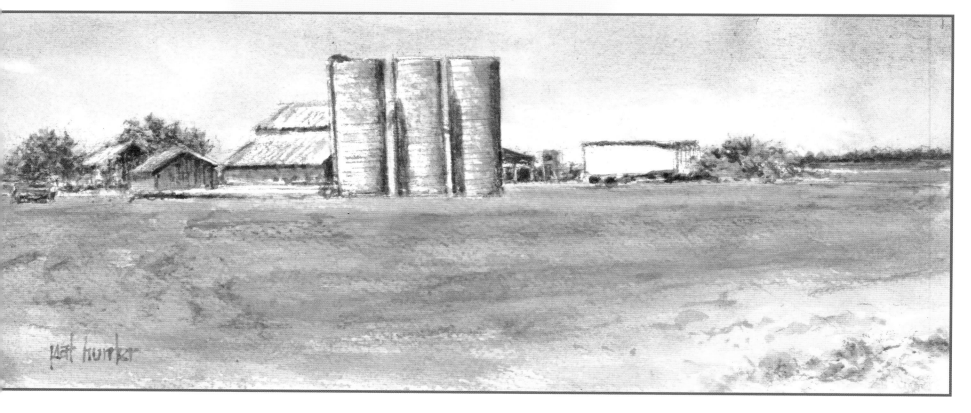

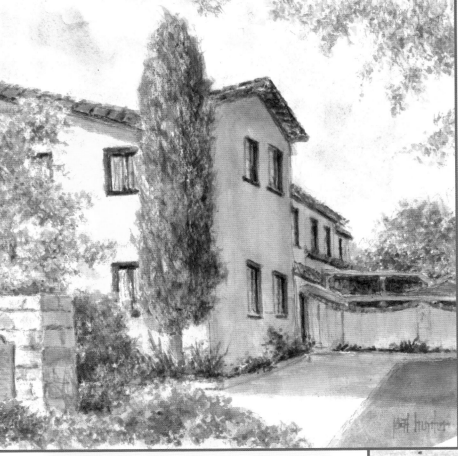

94 The Woolgrowers Restaurant

The Woolgrowers Restaurant, located at 609 H St. in Los Banos, is a 100-year-old Basque eatery in the heart of Los Banos. The family style restaurant features traditional French Basque recipes such as pigs' feet, ox tails, lamb shanks, and fish and shrimp scampi, besides traditional favorites of potato salad and fried chicken.

93 Espanas Restaurant

Espanas in Los Banos is a popular Mexican restaurant on the historic site of the Canal Farm Inn, headquarters for cattle baron and early pioneer Henry Miller. Miller founded Los Banos, and is credited with the planning and development of a vast gravity irrigation system in the 1870s.

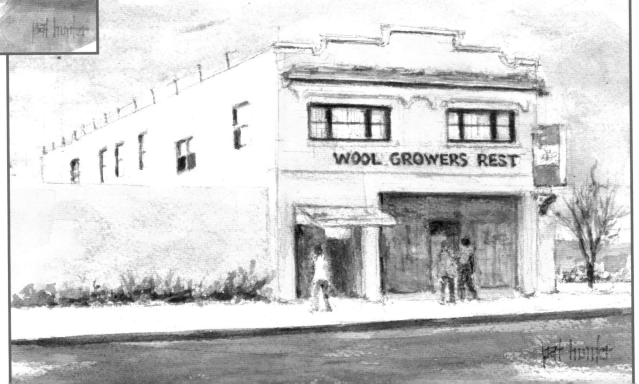

95 Farm Machinery

Farming requires year-round work, and in the winter, equipment maintenance and repairs are performed to ensure the harvest of tomatoes in the fields.

96 Produce Stand

Throughout the Central Valley, produce stands like this one in Los Banos entice buyers with fresh fruits, vegetables, and nuts.

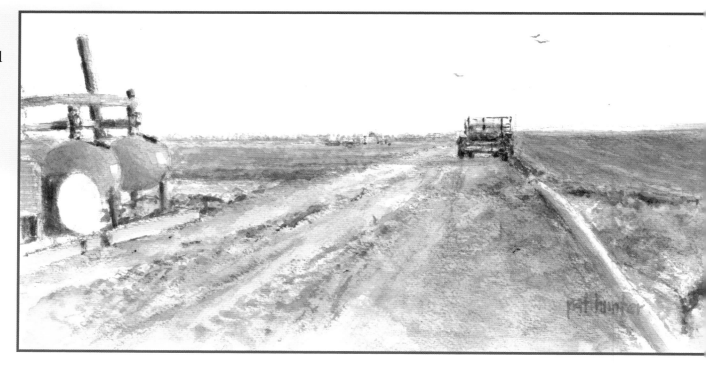

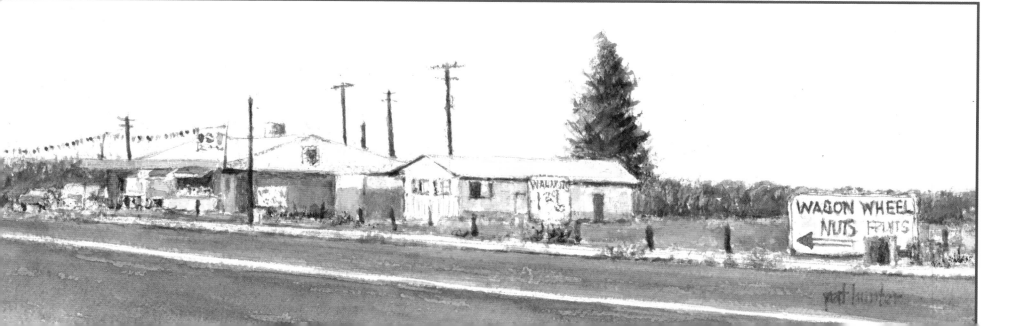

97 California Aqueduct

The California Aqueduct east of the San Luis Dam is considered to be the principal feature of the California State Water Project. The California Aqueduct consists of more than 400 miles of man-made tunnels, pipelines, and canals that distribute water collected from the Sierra Nevada Mountains to the valleys of Northern, Central, and Southern California.

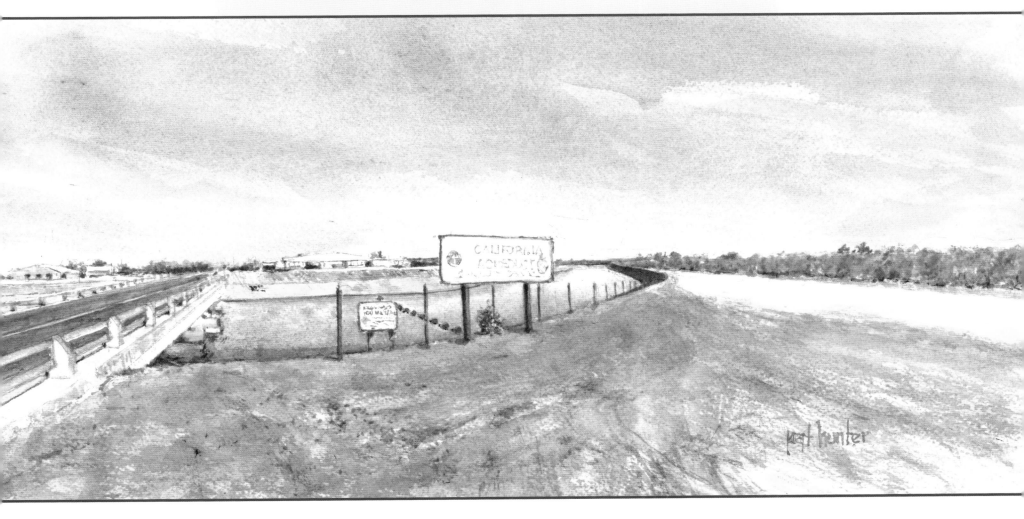

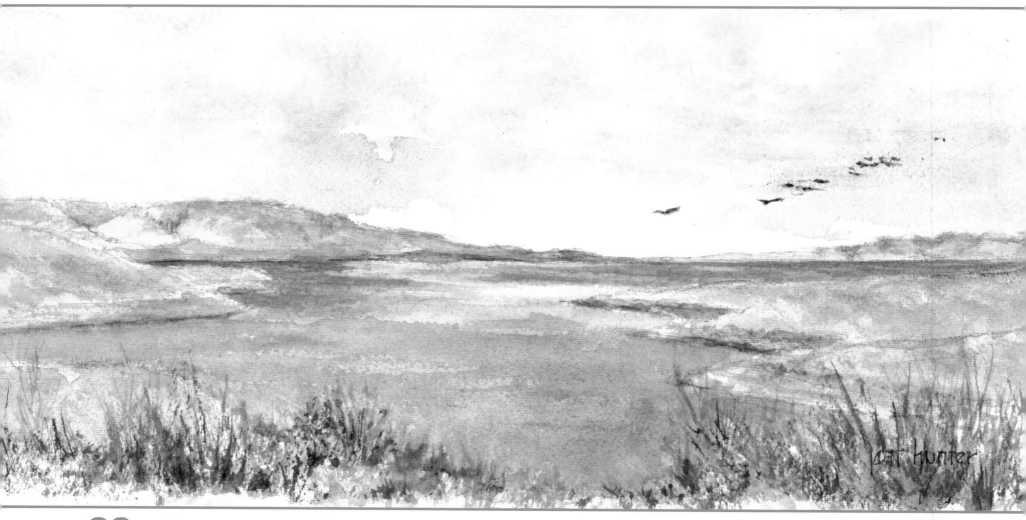

98 San Luis Dam

Construction on the San Luis Dam and Reservoir began in 1963 and was completed in 1968. The dam and reservoir are located in the Diablo Range east of Pacheco Pass on Highway 152 in Merced County. This major earth-filled dam forms the San Luis Reservoir, considered to be the largest off-stream reservoir in the United States. The San Luis Dam is owned jointly by the state and federal governments, and was constructed for the California State Water Project and the federal Central Valley Water Project. Aqueducts fed by Northern California rivers supply most of the reservoir's water.

99 **Mission San Juan Bautista**

Mission San Juan Bautista, the fifteenth mission, was founded on June 24, 1797, by Father Fermin Lasuen near Rio San Benito on a mesa overlooking the San Juan Valley. The mission, constructed directly over the San Andreas Fault, survived a series of earthquakes between 1798 and 1803. Of note is the Spanish plaza facing the mission. It is the last surviving Spanish plaza in California and is designated a State Historical Monument. A small section of the El Camino Real footpath leads from the agricultural fields to the central plaza in front of the mission.

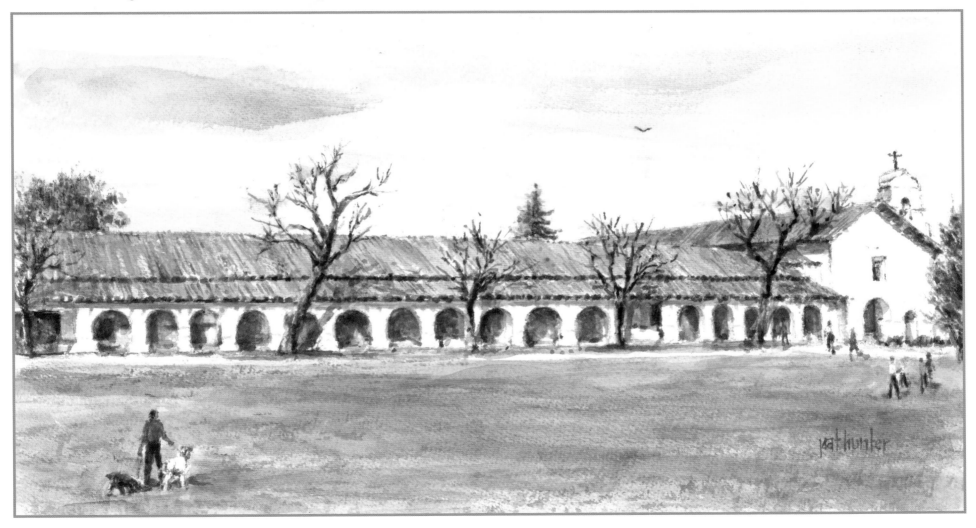

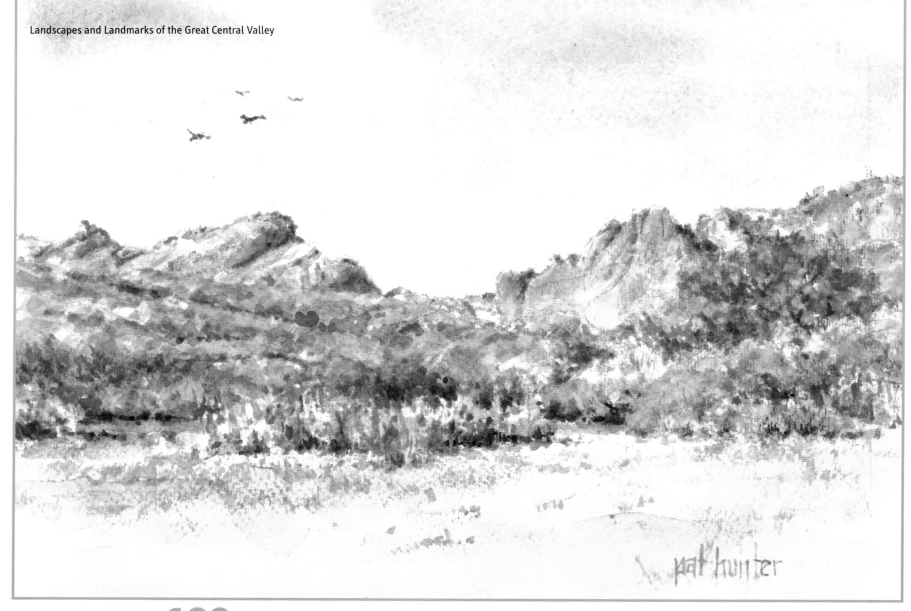

100 Pinnacles National Park

Pinnacles National Park lies within the Pacific Coast Range. The Pinnacles, the remains from an extinct volcano, are known for their rock formations, which provide habitat for falcons and California condors. Adventurers enjoy rock climbing and exploring talus caves (but should expect to encounter approximately thirteen species of bats). The park is managed by the National Park Service.

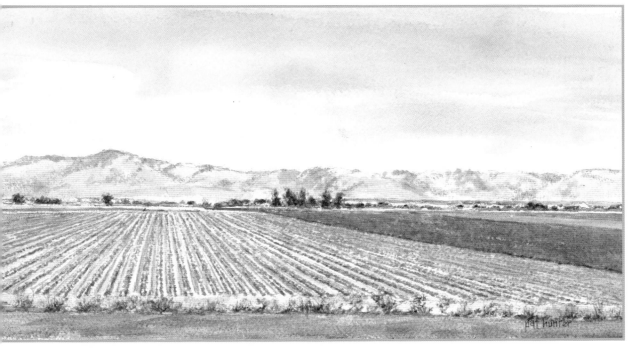

102 Castle Air Force Base

Castle Air Force Base, located northeast of Atwater and northwest of Merced, was in use from 1941–1995, serving as a United States Air Force Strategic Air Command Base. The base closed in 1995 and became the Castle Airport Aviation and Development Center. The former base now features artifacts of aviation history.

101 Agricultural Fields

Beneath coastal hills, a patchwork of fields stretches from the Central Valley to the coastal mountain range.

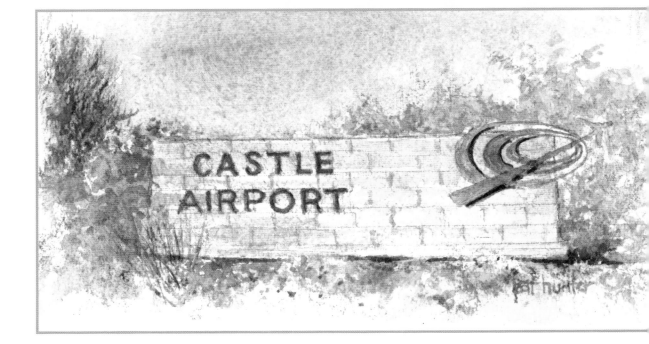

103 The Mail Pouch Tobacco Barn

Located south of Merced on Highway 99, the Mail Pouch
Tobacco Barn was one of many barns throughout the country
used for painted advertising during and after the 1930s. Only a
few remain in California.

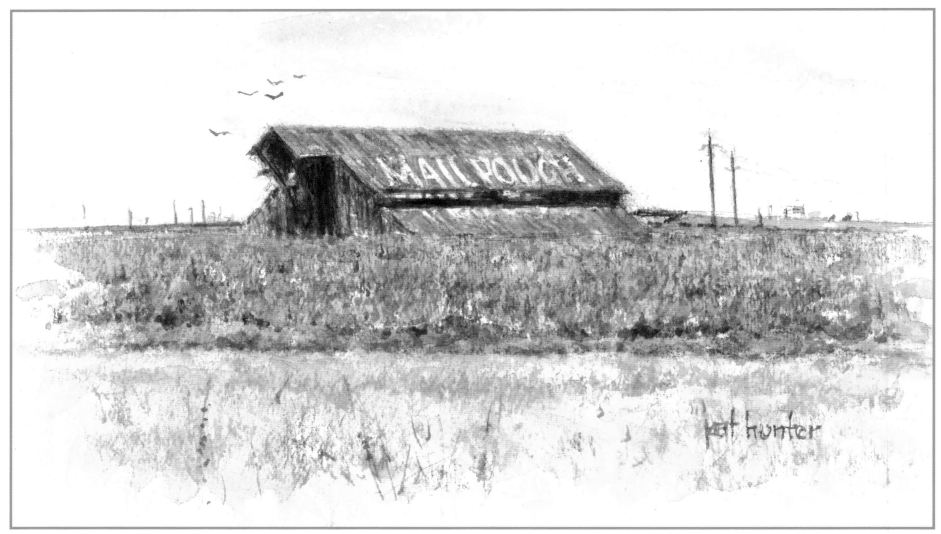

104 Barn on Highway 99

A rural landscape along Highway 99 includes a farm and tank house north of Madera.

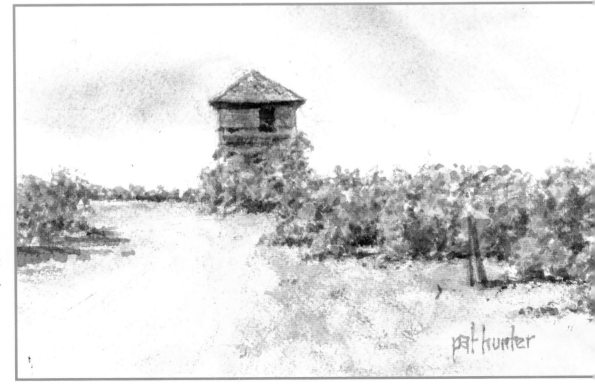

105 Tank House

A lone tank house stands amidst a field of grapes on Highway 99.

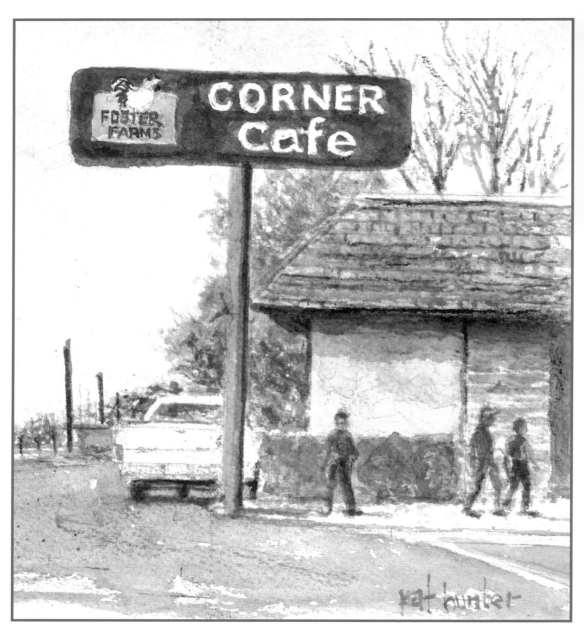

106 Livingston Foster Farms Café

The Livingston Foster Farms Café is a traditional family style restaurant. The café was originally opened to only serve Foster Farms employees; however, it is now open to anyone traveling Highway 99. Its signature menu includes poultry from the Foster Farm processing plant on the grounds.

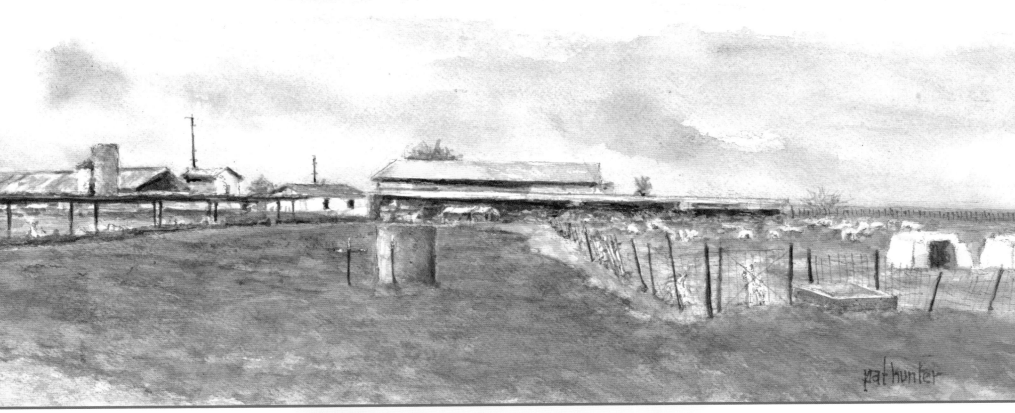

107 Turlock Goats

Goats in Turlock reside in goat houses, similar to dog houses, in their protected pens.

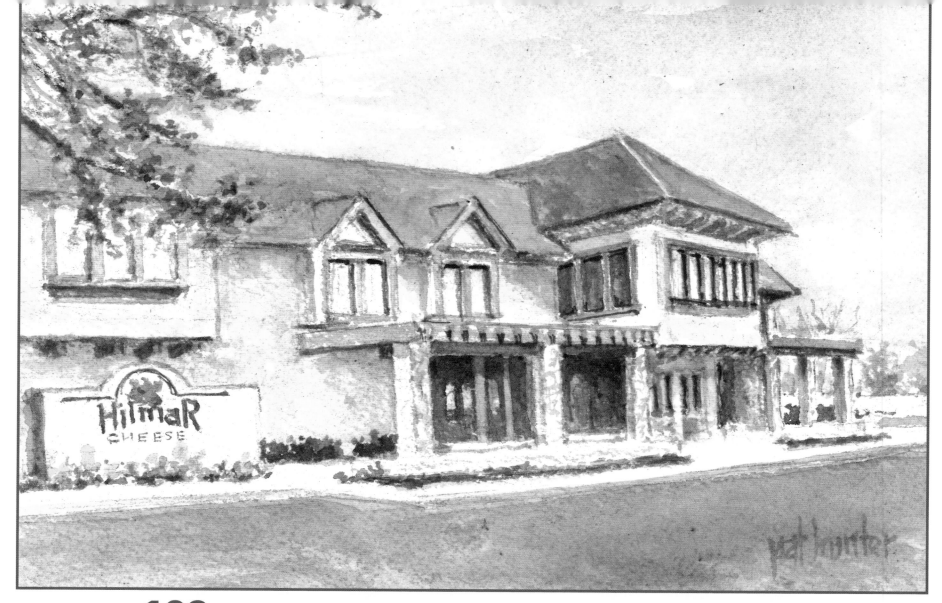

108 The Hilmar Cheese Visitor Center

The Hilmar Cheese Visitor Center, located on Lander Avenue in Hilmar, features a variety of cheeses, including Monterey jack, pepper, mozzarella, and cheddar, all manufactured on the grounds. Founded in 1984, the privately owned company employs more than 1000 people. An advertisement boasts: "Tour, Taste, Shop and Eat at the world's largest single-site cheese and whey factory, making more than 1 million pounds of cheese per day."

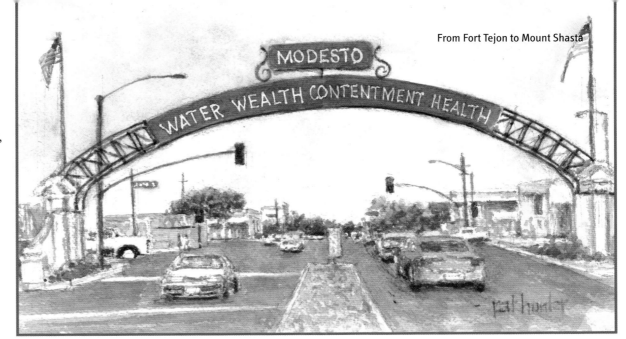

109 Modesto Arch

The Modesto Arch, built in 1912, bears the motto "Water, Wealth, Contentment, Health." The arch spans the intersection of 9th and I Streets, welcoming visitors and residents alike to Modesto.

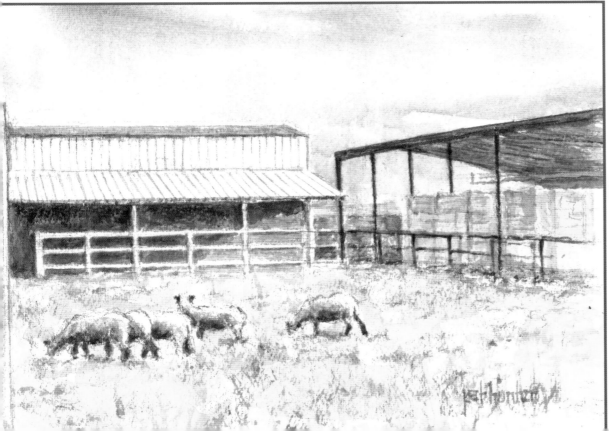

110 Modesto Sheep

Sheep from the Modesto Junior College sheep unit graze on the campus grounds. MJC is one of the most renowned agricultural junior colleges in the United States.

111 Coulterville Street Scene

This street scene in Coulterville reflects the historical gold rush town of the 1850s. A Registered California Historical landmark, Coulterville was established to provide supplies for the gold miners. More than forty structures remain as designated historic buildings from the mining era.

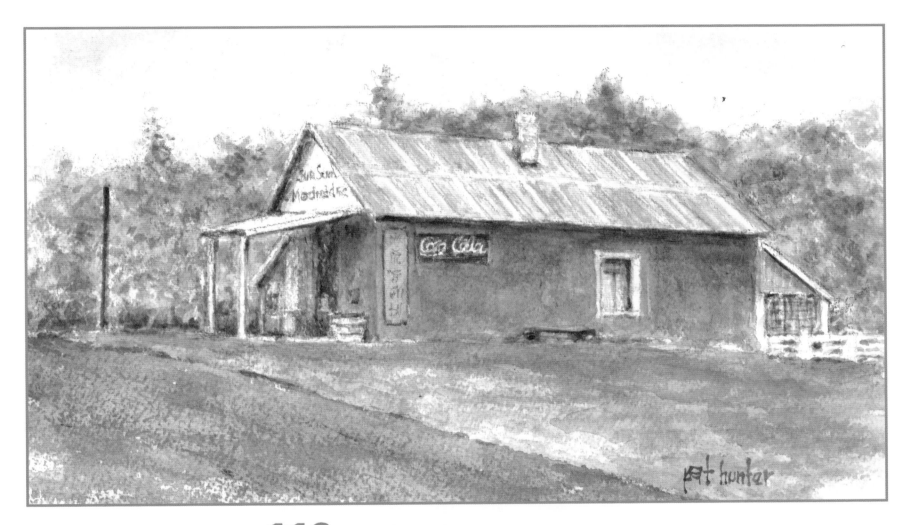

112 The Sun Sun Wo General Store

The Sun Sun Wo General Store, built out of
adobe in 1851, is one of a few remaining adobe
structures from the Gold Rush era.

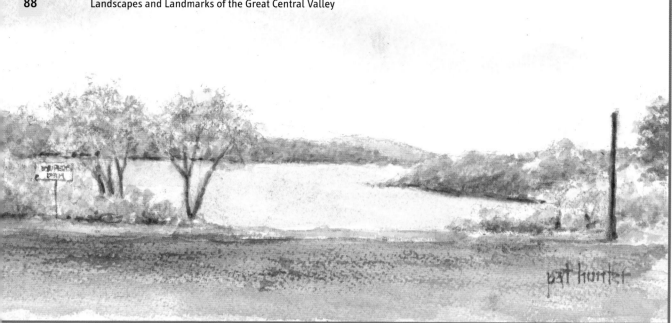

114 Hornitos

The well-preserved ghost town of Hornitos is a California Historical Landmark, but offers few structures to view. What does remain are a few walls and buildings from "little ovens," old Mexican tombs from the 1850s to the 1870s.

113 Lake Don Pedro

Reputed to be the sixth largest reservoir in California, Don Pedro Reservoir, or as it's familiarly called, Lake Don Pedro, was created after the construction of the New Don Pedro Dam across the Tuolumne River. It offers recreational boating and camping opportunities.

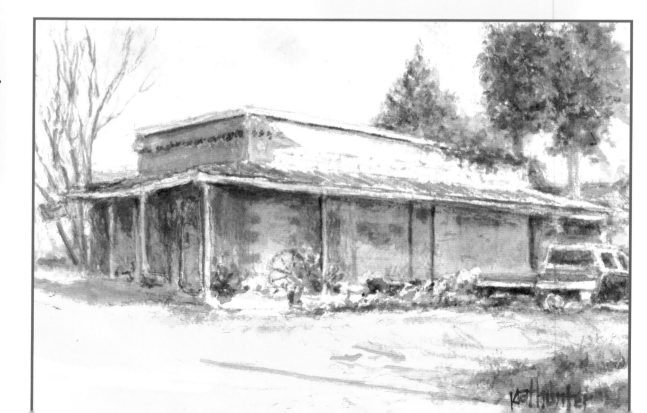

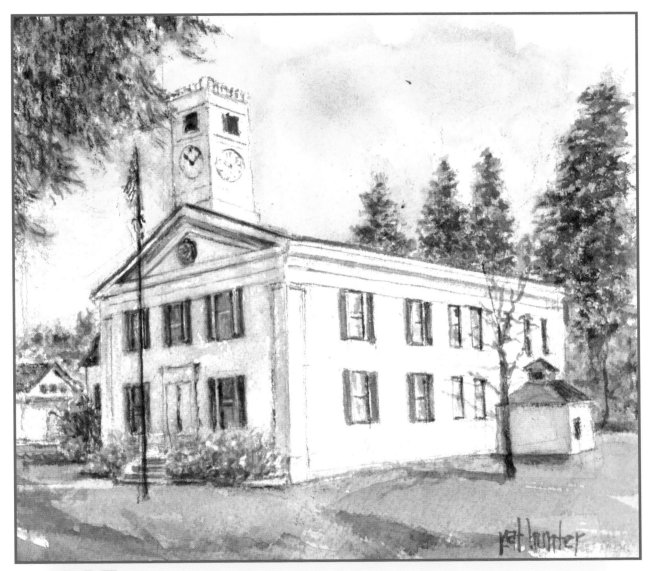

115 Mariposa Courthouse

The Mariposa Courthouse, built in 1854, is a designated California Historical Landmark. Not only is it the oldest superior courthouse in California, it is also the oldest courthouse in continuous use west of the Rockies.

116 St. James Episcopal Church

The St. James Episcopal Church, or "Red Church," located at 42 Snell Street in Sonora, was built in the post-Gold Rush year of 1860 in the Carpenter Gothic architectural style. This formerly Anglican church continues to offer services. It is the oldest Episcopal Church building in California and is a designated California Historical Landmark. The "Red Church" is considered to be the most photographed building in the Mother Lode.

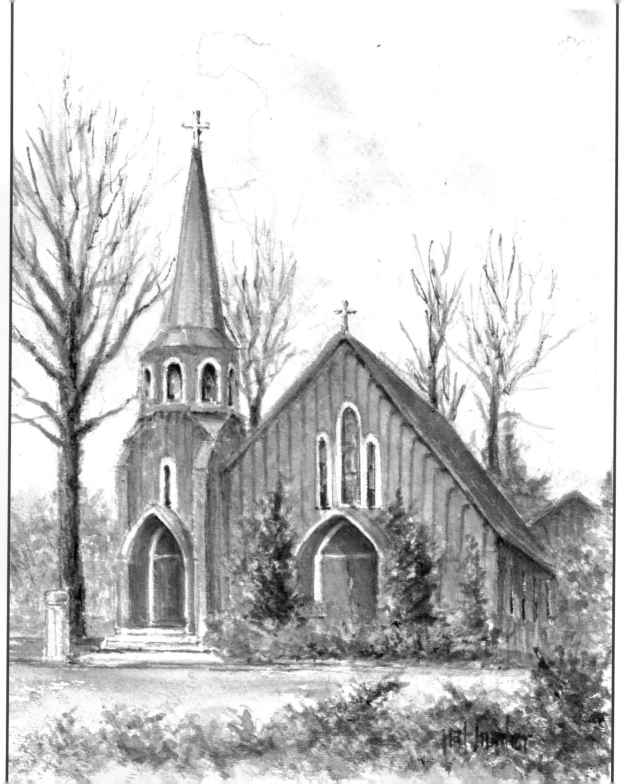

117 Columbia

Columbia, a 19th century mining town, is referred to as the "Gem of the Southern Mines." This boom town was founded in 1850 with the discovery of gold nearby. China House is one of several remaining businesses from the Gold Rush Era. Columbia is a designated California Historic Landmark and a National Historic Landmark.

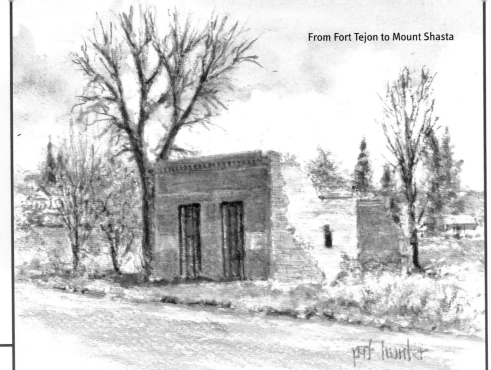

118 Wells Fargo Express Building

The Wells Fargo Express Building is a designated California Historical Landmark and a National Historic Landmark. The structure was originally built of wood, but burned down and was rebuilt with brick and iron in 1858.

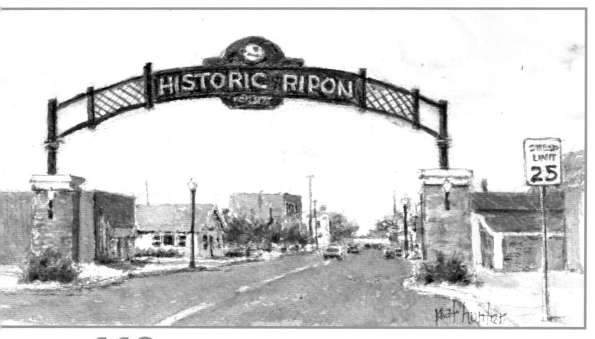

119 The Ripon Archway

The Ripon Archway over Stockton Street in Historic Downtown Ripon was completed in 2009, a construction project designed to preserve and promote the downtown district.

120 French Camp

The French Camp Elementary School at 241 E. 4th Street is located on the grounds of French Camp, the terminus of the Oregon and California Trail used by French and Canadian trappers with the Hudson Bay Company from 1832 to 1845. French Camp is the oldest settlement in San Joaquin County and is a California Historical Landmark.

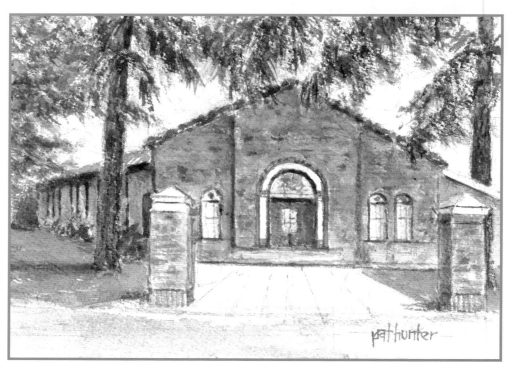

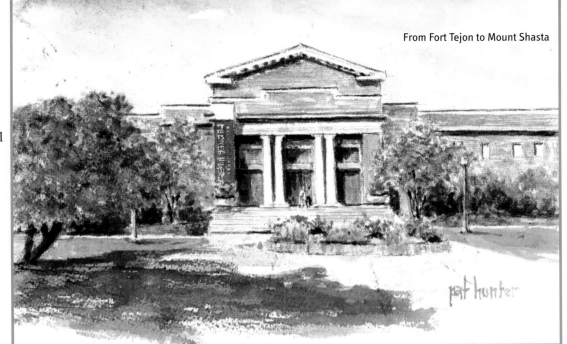

121 Haggin Museum

The Haggin Museum, located at 1201 N. Pershing Avenue in Stockton, features world-renowned art in both permanent collections and changing exhibitions, as well as educational programming and events.

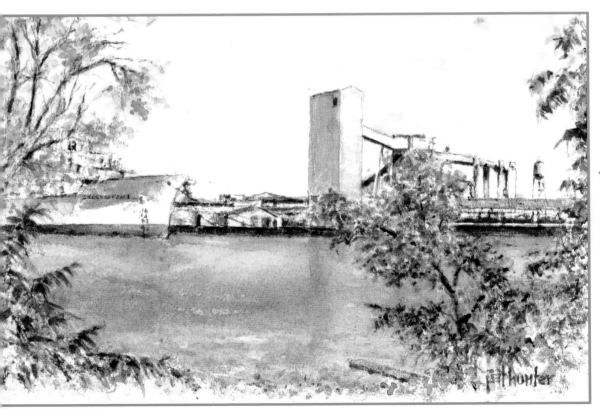

122 Stockton Port

The Port of Stockton, a major inland deep water port, is the farthest inland port in California.

123 **Old Stockton**
Although no longer in use, this boat launch
and adjoining building reflect earlier days.

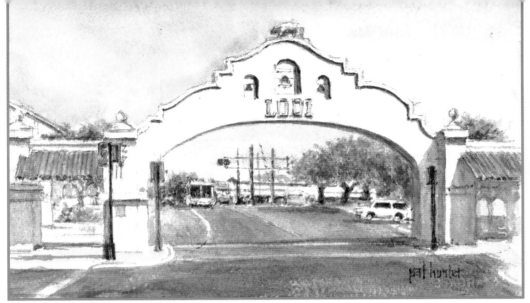

124 The Lodi Arch

The Lodi Arch, often referred to as the Mission Arch, features the mission revival architectural style. The arch, designed by architect E. B. Brown, was built in 1907 for the Lodi Tokay Carnival, a forerunner to the popular Lodi Grape Festival. A sculpture of the California Golden Bear was later added to the arch, as was the word "Lodi."

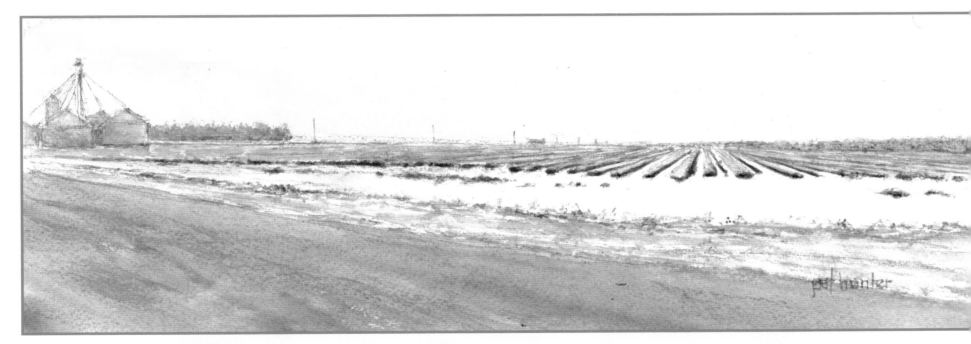

125 Sandhill Crane Festival

For over twenty years, the Sandhill Crane Festival has celebrated the return of migrating sandhill cranes to the marshes, delta wetlands, and reserves of the Lodi area.

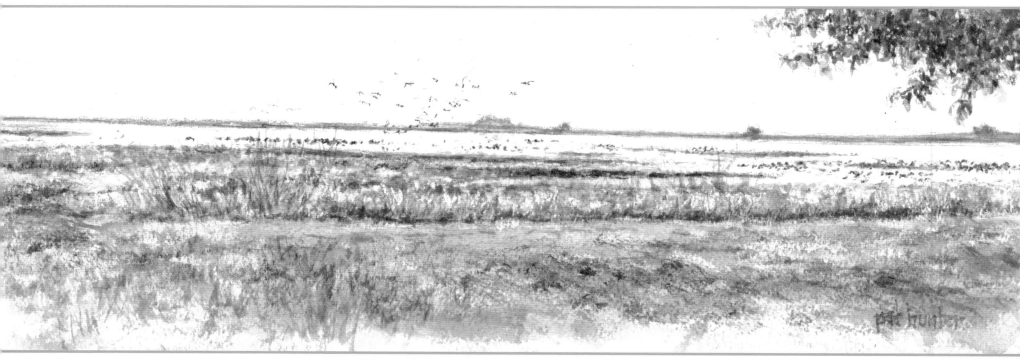

126 Crane Morning

Sandhill cranes fill the sky before swooping to the
flooded rice fields between Lodi and the Delta.

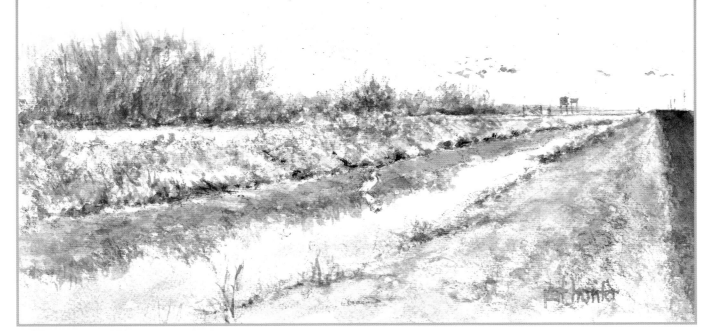

127 Lodi Landscape

An egret stands silently poised along the edge of a canal west of Lodi.

128 Galt Street Sculpture

The Galt Street Sculpture depicts bird watchers scanning the horizon, perhaps for sandhill cranes to rise from the wetlands. The sculptures at the Twin City Roundabouts reduce traffic congestion and visually enhance the entrance from Highway 99 to the city of Galt.

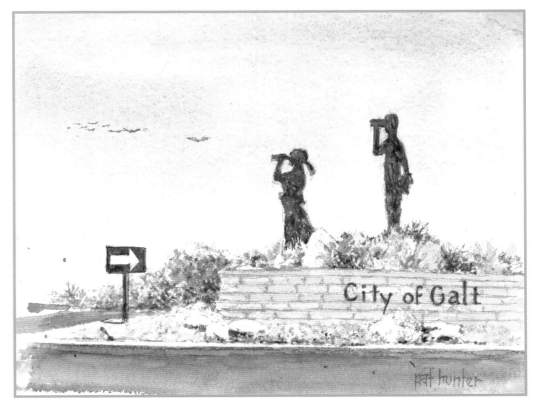

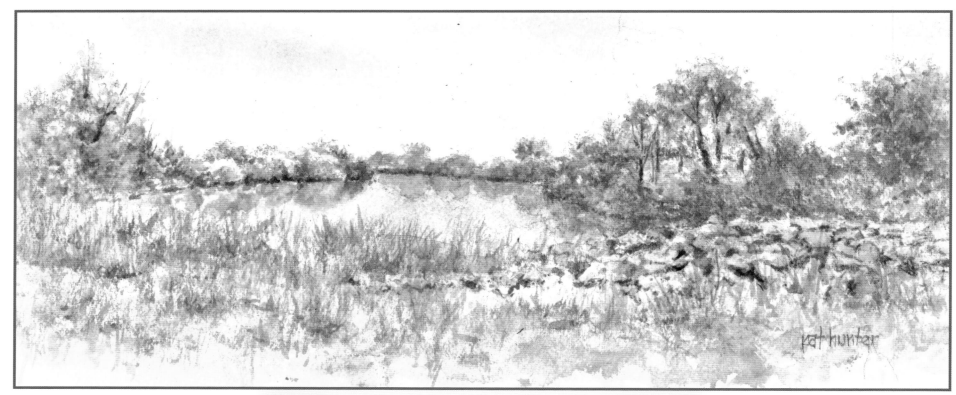

129 Reflection on the Delta

Reflections on the Sacramento/San Joaquin rivers of the California Delta are part of a peaceful setting for visitors taking a meandering excursion along its waters.

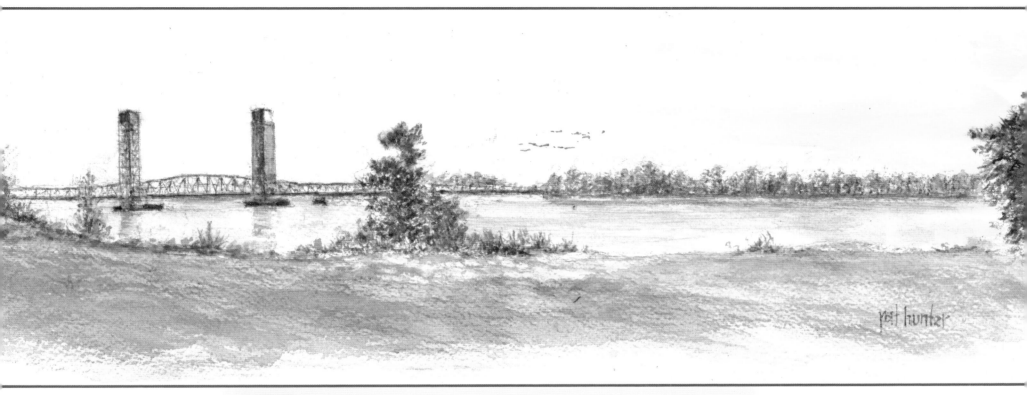

130 Rio Vista Bridge

The Helen Madere Memorial Bridge, commonly known as the Rio Vista Bridge, is a vertical lift bridge spanning the rivers of the Delta a half-mile from the Highway 12 and Highway 160 junction.

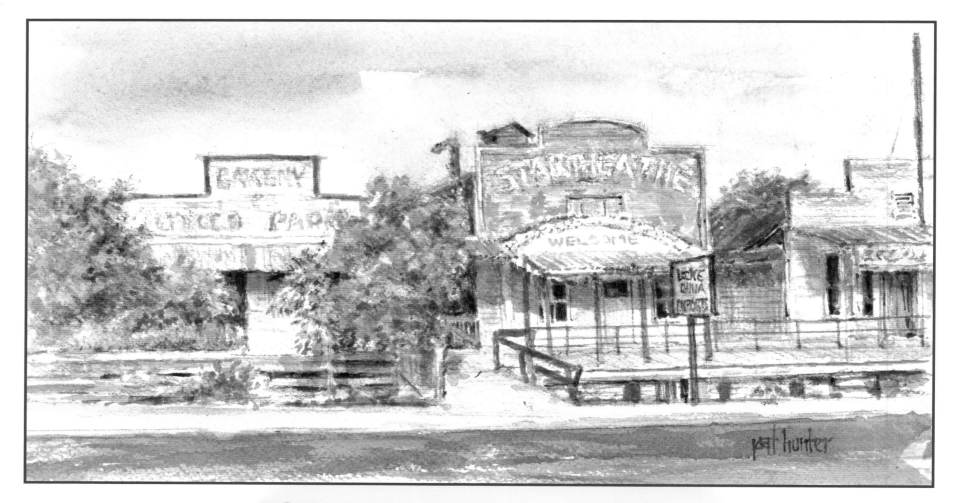

131 Locke Street Scene

The Chinese town of Locke, California, founded in 1915, is located on the Sacramento–San Joaquin River Delta. The highway-level street is part of the Locke Historic district, built by Chinese immigrants for Chinese. The Locke Historic District is listed on the National Register of Historic Places.

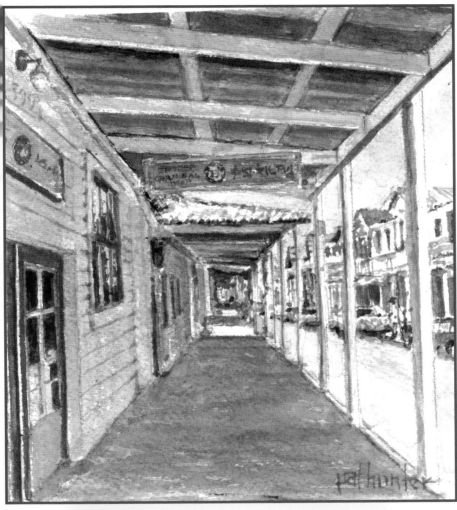

132 Locke Businesses

Locke's businesses are located a level below Highway 160 on Main Street, which is also known as River Road, in the Locke Historic District.

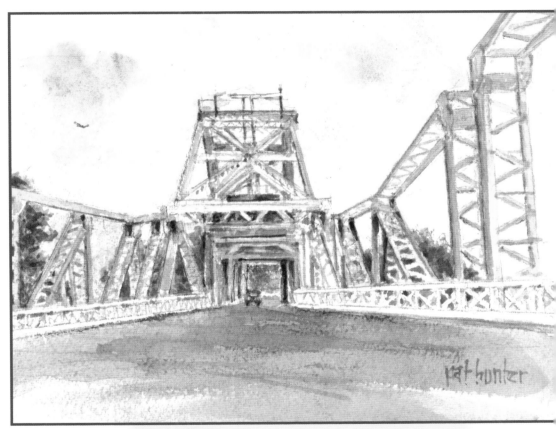

133 Drawbridge Locke

This drawbridge is one of many bridges across the Sacramento River.

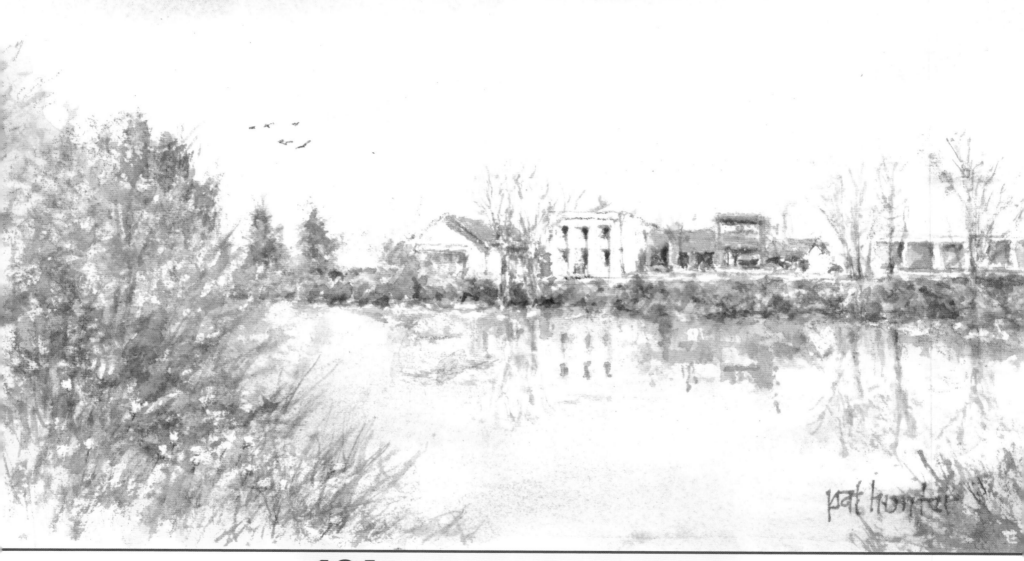

134 Delta Bird Habitat
The Delta provides a habitat for birds making their
migratory journey in the early spring.

135 Jackson Tailing Wheels

Built in 1914, the four Jackson Tailing Wheels were constructed to lift mining waste slurry from the Kennedy Gold Mine. Located at the 1200 Block of Jackson Road, Jackson, the Jackson Tailing Wheels are listed on the National Register of Historic Places in Amador County.

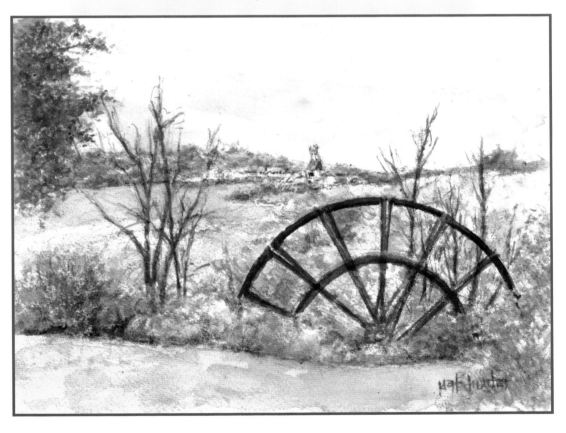

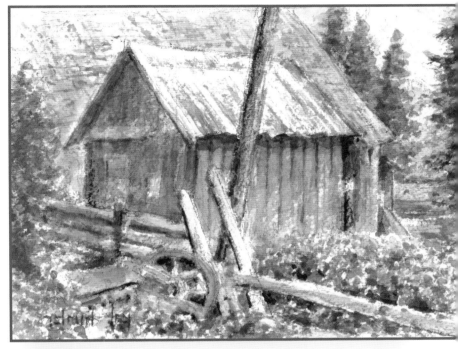

136 Volcano Daffodil Hill

Pioneers Arthur Burbeck and Lizzie Van Worst McLaughlin established their home site in Volcano in the mid-1800s. The site became The McLaughlin's Daffodil Memorial Garden, a massive hill carpeted in daffodils which bloom profusely in the spring.

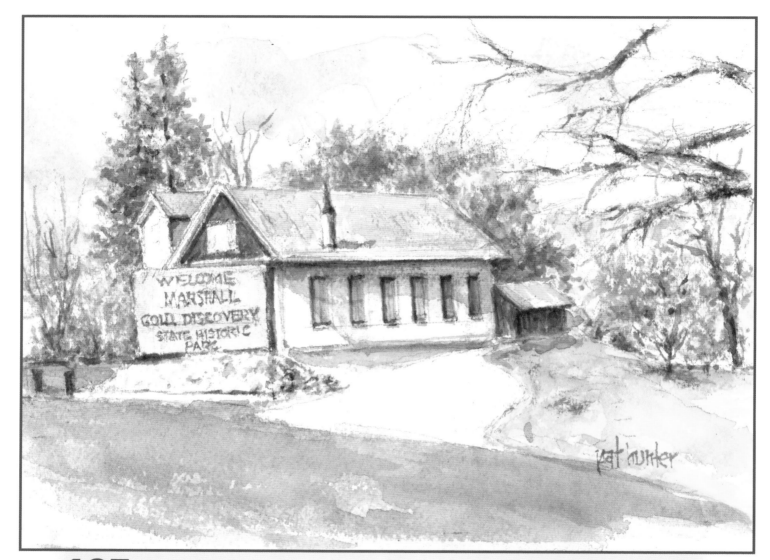

137 Coloma Marshall Gold

When James W. Marshall discovered gold flecks in the sawmill he was working on with John Sutter, he launched the massive California Gold Rush. Two monuments commemorate the discovery, one for the spot where the gold was found and the other to honor Marshall. The Marshall Gold Discovery State Historic Park is a National Historic Landmark District.

138 American River

The South Fork of the American River flowing through Coloma behind the Marshall Gold Discovery State Historical Park is a popular spot for summer rafting and kayaking.

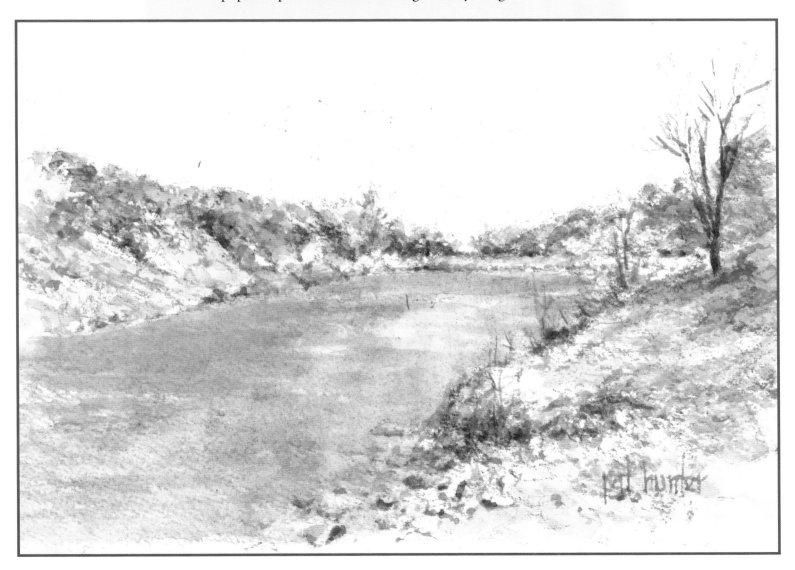

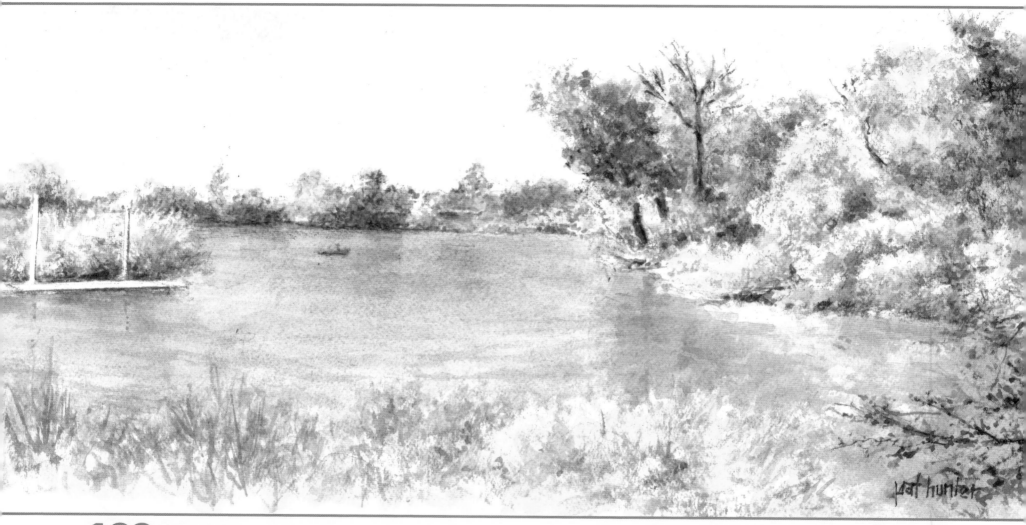

139 Confluence of the American and Sacramento Rivers

The 120-mile-long American River in California flows from the Sierra Nevada Mountains to where it meets the Sacramento River in the Sacramento Valley. The Sacramento River is the longest river in California, flowing south of Mount Shasta in the Klamath Mountains for 400 miles until it joins the American River. The confluence of the two rivers continues on until it enters the Sacramento–San Joaquin River Delta.

140 Sutter's Fort State Historic Park

In 1839, John Sutter established the agriculture and trade colony of New Helvetia, under the province of Mexican Alta California. He began construction of Sutter's Fort three years later. The fort was the first non-indigenous community in the Central Valley. Once gold was discovered, the fort was abandoned for the Gold Rush. The Sutter's Fort State Historic Park has been restored and operates under the California Department of Parks and Recreation. It is a designated National Historic Landmark.

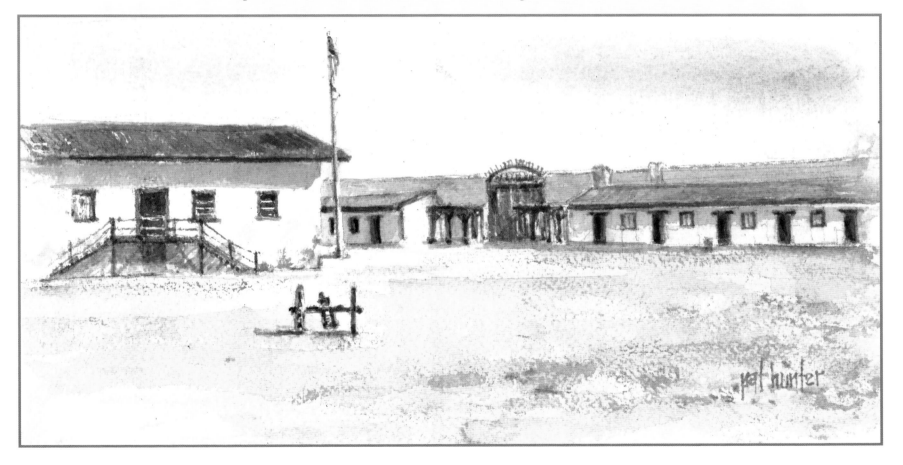

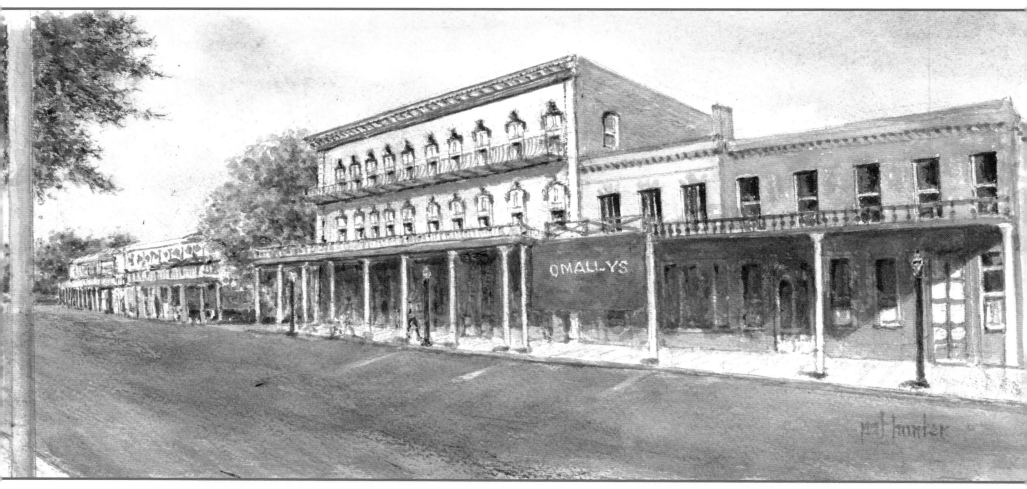

141 Old Sacramento State Historical Street

With the discovery of gold, the Sacramento area business community grew rapidly to accommodate the needs of the burgeoning population of miners. Of note, Sacramento's city streets were built a level higher than the usual streets due to constant flooding, an approach to construction which as a by-product created tunnels and basements beneath the streets.

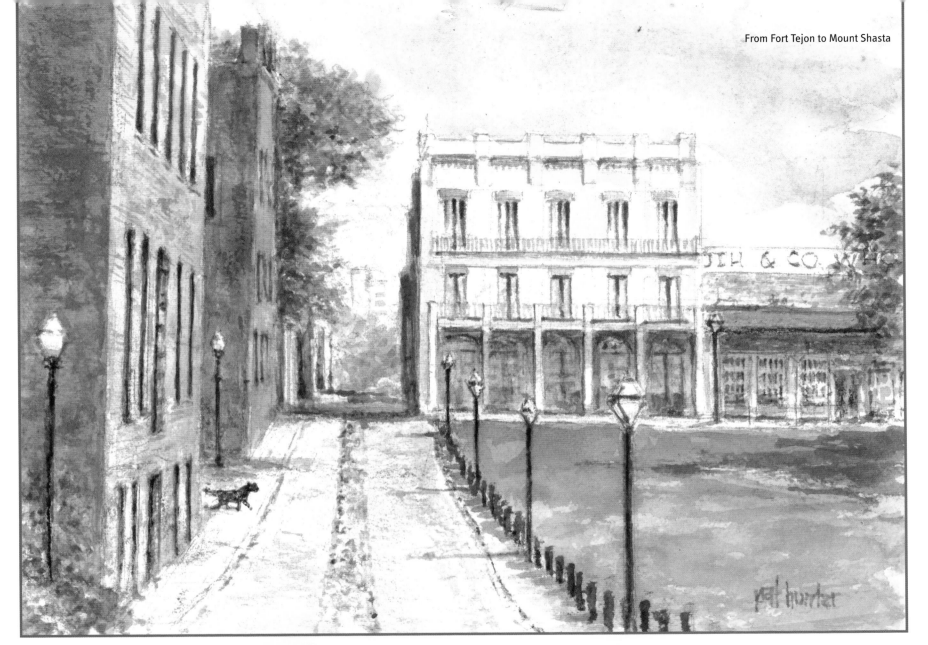

142 **Old Sacramento Alley**
The side streets of Old Sacramento Alley offer a wealth
of opportunities to discover hidden treasures.

143 State Capitol

The California State Capitol houses the government of California. The Capitol's construction began in 1860 and was completed in 1874. M. Fredrich Butler, architect, designed the stately old building in the neoclassical architectural style. The Capitol, located at 10th and L Streets in Sacramento, is listed on the National Register of Historic Places, is a US National Historic District Landmark, and is a California Historical Landmark.

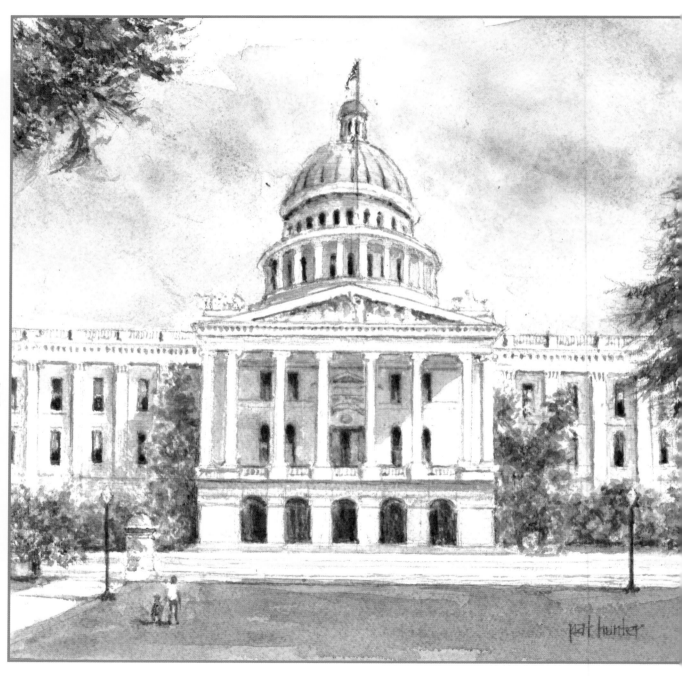

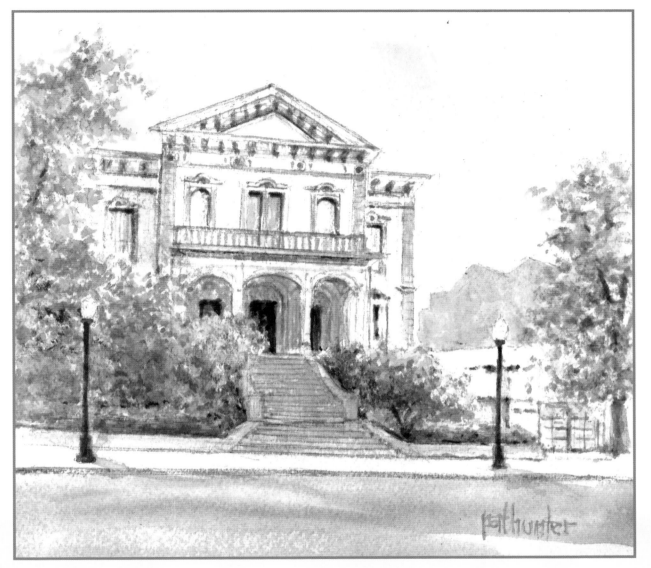

144 The Crocker Mansion

Judge Edwin B. Crocker purchased property at 3rd and O Streets in Sacramento in 1868, and later enlisted architect Seth Babson to expand his home into a large mansion with an Italianate architectural design. Crocker then commissioned Babson to create an art gallery on the adjacent property. That art museum, begun with Crocker's private collection, evolved into the Crocker Art Museum in 1978, and is renowned for its premier European art collections and ceramics, as well as its exhibitions and art educational programs. The Crocker Art Museum is a California Historical Landmark and listed on the National Register.

145 The Leland Stanford Mansion State Historic Park

The Leland Stanford Mansion State Historic Park, a federally protected historic site two blocks from the state capitol in Sacramento, features the home of Amasa Leland Stanford and his wife Jane. An American tycoon, former California Governor and United States Senator, president of the Southern Pacific Railroad and of the Central Pacific Railroad, Leland Stanford is best known for founding Stanford University with his wife. Jane Leland donated their home to the Catholic Diocese of Sacramento to shelter and care for homeless children. After the Stanford Home for Children relocated, the property was purchased by the State of California to serve as a state park. The Leland Stanford House is listed on the U.S. National Register of Historic Places, and designated a U.S. National Historic Landmark and a California Historical Landmark.

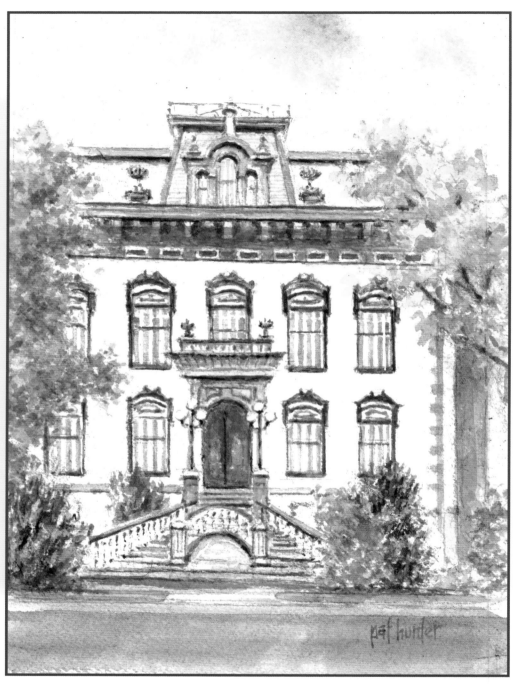

147 Cal Expo

"Farm to Fork" is the fitting motto of the California Exposition and State Fair. Cal Expo's origins trace to an organized agricultural exposition in 1854 in San Francisco to promote and showcase the state's farming and agricultural industries. Several cities housed the Expo throughout the years, until it finally made its home in Sacramento, where a permanent site was purchased. The State Fair began in 1909 on Stockton Boulevard, and has been held at the current Cal Expo site since 1968. Cal Expo hosts numerous additional events as well.

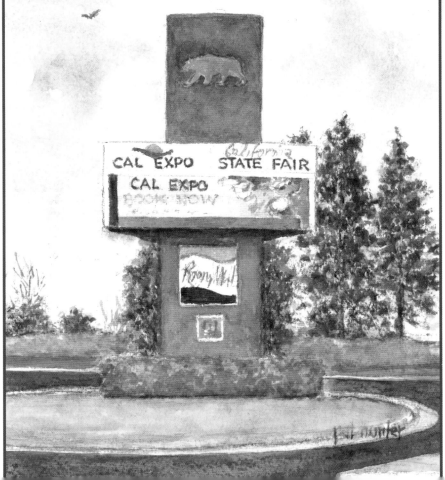

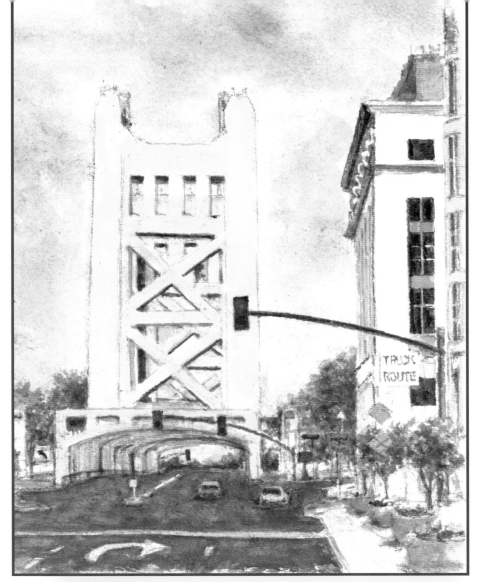

146 Tower Bridge

The Tower Bridge in Sacramento, a vertical lift bridge, links west Sacramento to Yolo County. The historic gold tower bridge, constructed in 1937, was designed by architect Alfred W. Eichler in the Streamline Moderne architectural style.

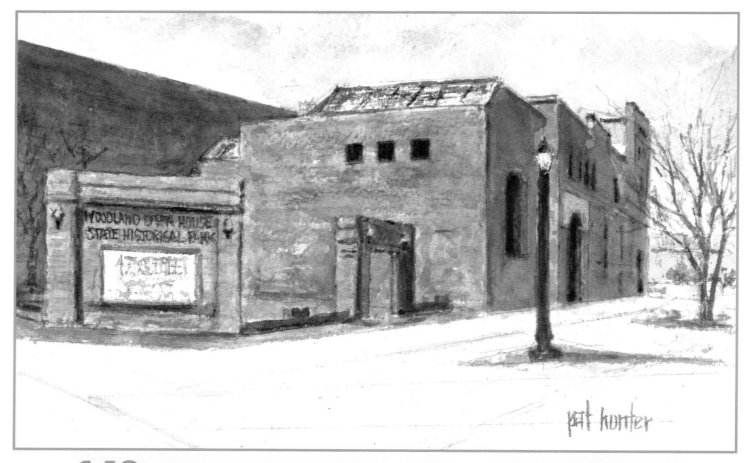

148 Woodland Opera House

Listed on the National Register of Historic Places and a California Historical Landmark, the Woodland Opera House is one of only four 19th Century opera houses in California. Located at 340 2nd Street, the Opera House was designed by architect Thomas J. Welsh in the 19th Century American Playhouse style in 1885. The building was destroyed by fire and then rebuilt from 1895 to 1896. It sat empty from 1913 to 1971, but was restored and reopened in 1989.

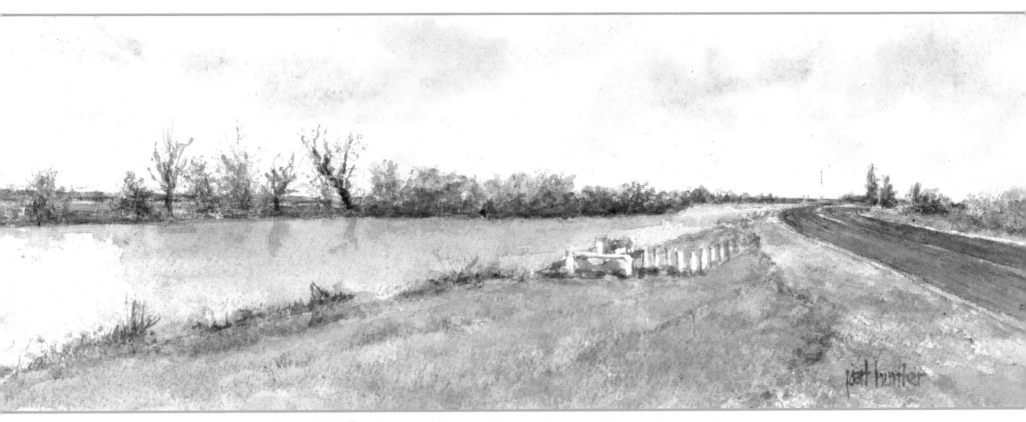

149 Knights Landing

Knights Landing began as a steamboat landing located on the Sacramento River in Yolo County. Legend has it that "Black Bart," whose real name was Charles Bolles, is buried in an unmarked grave in the local cemetery.

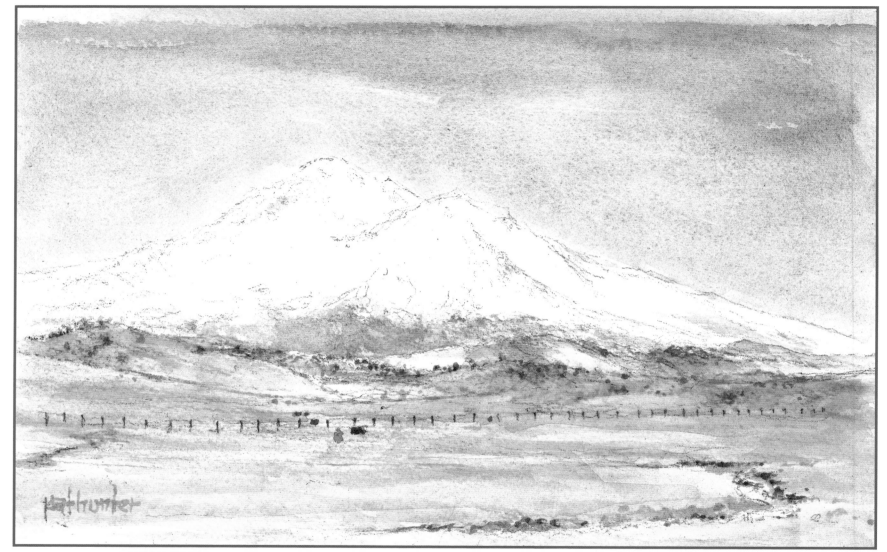

150 Mount Shasta

Mount Shasta is a potentially active volcano located in the Shasta–Trinity National Forest in the Cascade Range. Mount Shasta has long been a massive landmark along the Siskiyou Trail, which follows the path established by Native Americans linking California's Central Valley and the Pacific Northwest. Mount Shasta is a designated National Natural Landmark.

Closing

Our trek through the Great Central Valley concludes with our return to Mount Shasta, familiar to us from our trips to Yreka and the border of Oregon. We end our journey with a reinvigorated appreciation for our agricultural inheritance. This land that feeds the world is abundantly vibrant, glowing with constant renewal from the nutrients of the soil and the accommodating climate.

The landscapes presented in these art-filled pages represent only a portion of the many discoveries we made during our travels, and the numerous landmarks we saw remind us of the history still richly evident in the many large and small communities that dot the Valley. The Valley's agricultural production depends on the families who reside in these communities, and others who come in to plant the fields and harvest the crops.

We relished the opportunity to traverse our home state, where the Great Central Valley seems to be just the right distance between the snow-topped mountain ranges to the east and the vast ocean to the west. We invite you to take the inland jaunt from the Interstate 5 Grapevine/Fort Tejon area to the volcanic majesty and drama of Mount Shasta. Explore the vistas we discovered. And find your own treasures along the way.

Discover. Appreciate. Protect our Great Central Valley.

The Pat Hunter and Janice Stevens Collection
Breathtaking artwork of California's most beautiful places

**An Artist and a Writer
Travel Highway 1 North**

$21.95 • 120 pages • color illustrations
Paperback • ISBN 978-1-61035-053-2

**An Artist and a Writer
Travel Highway 1 Central**

$26.95 • 132 pages • color illustrations
Hardback • ISBN 978-1-61035-219-2

**An Artist and a Writer
Travel Highway 1 South**

$26.95 • 142 pages • color illustrations
Hardback • ISBN 978-1-61035-297-0

**Remembering the
California Missions**

$26.95 • 130 pages • color illustrations
Hardback • ISBN 978-1-884995-64-4

**Fresno's Architectural Past
Volume 1**

$26.95 • 76 pages • color illustrations
Hardback • ISBN 978-0-941936-97-2

**Fresno's Architectural Past
Volume 2**

$26.95 • 76 pages • color illustrations
Hardback • ISBN 978-1-933502-13-7

**William Saroyan:
Places in Time**

$26.95 • 88 pages • color illustrations
Hardback • ISBN 978-1-933502-24-3

AVAILABLE FROM BOOKSTORES, ONLINE BOOKSELLERS, AND
CRAVENSTREETBOOKS.COM, OR BY CALLING TOLL-FREE 1-800-345-4447